THE PICTURE WALL

ONE WOMAN'S JOURNEY OF BEING (HIS) (HER) THEIR MOTHER

C. A. GIBBS

ISBNs

Paperback: 978-1-989059-60-9

eBook: 978-1-989059-61-6

Hardcover: 978-1-989059-62-3

Audio: 978-1-989059-63-0

PRAISE FOR THE PICTURE WALL

One of the greatest illusions of mothering is that we can determine our child's path in life. Adjusting to a reality in conflict with what we have imagined for our child, is the beginning of an emotional journey, one that is not told often enough. C.A. Gibbs describes her experience of that journey in The Picture Wall: One Woman's Story of Being (His) (Her) Their Mother with courage and honesty. Choosing to support her child's best authentic life means letting go of the familiar and finding her way in all new terrain. Gibbs' book can serve as a guiding light for mothers whose children live outside societal norms and expectations.

— JUDITH FRIZLEN, AUTHOR,
UNPACKING GUILT: A MOTHER'S
JOURNEY TO FREEDOM

For some of us, the child that we expected is not the child that we got. C.A. Gibbs' book is a story about her travels as a mother on an unexpected path. It is a tale of acceptance, celebration and loving our children unconditionally just the way they are.

— SUE ROBINS, AUTHOR, BIRD'S EYE
VIEW: STORIES OF A LIFE LIVED IN
HEALTH CARE

By all accounts The Picture Wall is a heart moving story depicting the transformation of a family through the mystery of gender identity. This story is so necessary for us to hear as we, as a culture and society, are just beginning to open our eyes to the fluid way that gender presents itself to us. Using the metaphor of the family's photographic display, depicting the milestones of each precious member, Mrs. Gibbs takes us through the arduous passage of a different development. A dual story of awakening of the heart of a mother towards her transgendered child and of the child's awakening to his, her, their fluidity of gender. Mrs. Gibbs portrayal of her enduring journey is raw, honest, and hopeful in the deepest sense of the heart.

Taking place in a traditional Christian home, Mrs. Gibbs portrays her own upbringing as the fertile ground that she drew upon in defining her role as a mother. Built into her understanding was a grave sense of responsibility, further enhanced by her own fragile health and the treasured birth of two miraculous children. Her own childhood experience gave her a recipe for success.

Spiritual leader and guide, she was to shape her family through right actions, just as in a recipe that is faithfully followed, producing right fruit and clear identity. Through the lens of unconditional love, we are given an intimate look at the shift in paradigm that this courageous family was able to make, as the recipe no longer fit. Clearly, she was not the only cook. A greater force at play, we are given opportunity to wrestle with our conceptions of human gender; we have a Creator who paints his children with a great variety of colors. We are at the beginnings of

grasping the remarkable multiplicity of the human form.

The dream of a world full of definitive answers is regularly and often rudely interrupted by the reality that while we like to think in black and white, grey is the predominant shade in the human experience. This book lovingly provides proof of this. It is a story of deep commitment, and great courage. It illustrates the depth of character required to survive revolutionary change and come out the other side with new appreciation for the complexities of life. It is an enlightening and meaningful read.

Our children are supposed to be loved unconditionally, but what does that really mean? In her book, The Picture Wall, C. A. Gibbs pursues the concept with each step she takes with her autistic son who later became her transgender nonbinary adult. Her gut level honesty is both haunting and breathtaking. From the beginning the reader is taken page turn by page turn on her journey to be the best mother she knew how to be. Along the way her every expectation of motherhood was tested as was her faith. In the end, her insight led her to understand that what she learned about unconditional love happened in her church. With the suicide rate markedly higher in trans children and adults, The Picture Wall is a must read.

— *YVONNE K. CAPUTO, AUTHOR,*
FLYING WITH DAD: A DAUGHTER, A
FATHER, AND THE HIDDEN GIFTS IN
HIS STORIES FROM WORLD WAR II.

CONTENTS

To motherhood.
You have compelled me to grow in ways I never dreamed possible. You've challenged me to reflect on who I was, who I needed to become, and to adjust my expectations—of myself and others.

PROLOGUE

I remember moving day. I left our home in the city, just me and our parakeet in the car, with the last load of stuff crammed around us. I had only visited this new town as a passenger while my husband, Dave, navigated back roads. On this day, I took the direct route for the first time, exiting the freeway and driving the country highway leading to our new town. I took in the view. August fields of hay, corn, and pumpkins—dotted with cow pastures—spread for miles on my left while a lazy river meandered on the right. The loss I felt over leaving the life I loved in the city became tears of joy and gratitude. I never thought I'd be fortunate enough to live somewhere so beautiful, but this was to be our new home.

Over the next twenty years, I drove that route thousands of times. The only thing about that stretch of highway to change in that time was the crops growing in each field. However, urban sprawl eventually reached our town. After years of legal battles over construction in a flood zone, developers have bought most of the farms, and the for-sale signs adorning each field sport big red stickers that say sold. Construction will soon begin, and by this

time next year, the valley's swath of farmland will be trans-
formed into a truck stop, several car dealerships, and retail
establishments.

While I lament the loss of fertile farmland and the
change to our way of life, the people who have lived here
for generations have an even more idyllic place embedded
in their memories. Dairy cows were once the lifeblood of
this town. The land where my church and two public
schools sit was once a single dairy farm. The grocery store,
another public school, and a collection of apartment
dwellings were built on a dairy farm belonging to another
family. Our entire block used to be part of another dairy
farm. In fact, the Country Delight dairy sign is still on the
barn down the street, now repurposed as a thrift store, and
the town's original high school building, built in 1934 and
replaced with a more modern structure, had a milking
parlor in its basement, where they used to teach the next
generation of dairy farmers.

Today, trucks loaded with fill dirt rumble past my
house daily as construction begins on a new housing
development that will sprout on top of Country Delight's
old cow pasture.

Many here want to hold on to the old small-town
ways, which is easy to do when you visit the downtown
core and walk the residential streets where I live. As the
farming roots of our community are paved over, living on
only in our memories, downtown is quickly becoming all
that remains of the unique small-town identity.

The people here like to get together and celebrate. We
love parades! We have a classic, old-fashioned main street
that is about a quarter mile long and serves as the show-
case for our two-hour Fourth of July parade, a high school
homecoming parade, Veteran's Day parade, Santa parade,
and Memorial Day parade. The same street closes down
for car shows, street fairs, high school lip-dub filming, and

trick-or-treating at the local businesses. These gatherings help us connect and enjoy a sense of belonging.

We moved here as young parents of a new baby, with Dave embarking on a new job. We established ourselves as part of the community by joining the local Catholic church, making friends with interesting people, and participating in community events. One evening in October, after we sat down to dinner, the baby in his highchair, we heard a commotion on the street in front of our house. We bundled our son in a blanket and went outside to investigate. The street was alive with high school kids lining up their floats for the Homecoming parade! This place revealed amazing secrets, and we were thrilled to claim it as our home.

Our son Matthew grew, another baby joined the family, and over time the sights and sounds of family life evolved too. My heart nearly burst with joy the night I stood on the sidewalk and watched Matthew, then in high school, march in the traditional Homecoming parade for the first time.

Dave and I now live in an empty nest, and time has turned us into very different people from those young parents of yesteryear. Our love and commitment to each other and our children remain at the core of who we are, but like our hometown, change would be an inevitable part of how our lives played out.

I simply had no idea how big that change would be.

SECTION I: HIS MOTHER

SOMEDAY BABY

I've always wanted to be a mother. When I was a girl, I practiced being a good mommy to my dolls when we played house. I was the mom as often as my friends would agree to it. By the time I was a teenager, I knew that our social norms expected me to be more than a mother (*what more could there be?* I wondered) and to choose a career path using the education that I was fortunate enough to pursue.

One crisp fall day, as I took my seat in the university's second-year Spanish class, my ears perked at the animated chatter of my classmates. "Have you heard? There's a new program being introduced for students to earn a minor in bilingual education. And they're offering scholarships!" *Teaching? Bilingual education?* It sounded perfect. I loved the idea of spending tons of time with kids, fostering creative energy, using my Spanish skills, and helping the under-served in the community. *Yeah, sign me up!* I threw myself into the world of teacher jargon for the following three years and could speak whole language and total physical response with the best of them.

Dave and I met at the dining hall's salad bar through an awkward introduction by a mutual friend. We'd been minding our own business and helping ourselves to dinner when a friend elbowed his way into the narrow space between us. Having noticed the cute boy next to me, I chastised my friend on his rude behavior.

With a hangdog look, my friend apologized, then introduced us. "This is Dave Gibbs, and he's going to sit with us tonight."

After an amazing number of coincidental run-ins that I may or may not have orchestrated (nudge nudge wink wink), including meals that mutual friends had invited us to and dances we both attended, by December we were dating. At least, dating by poor-college-student standards: our dates involved going to the dining hall, studying at the library, and occasionally buying Big Gulps at the local 7-11. By January, we were in love.

Dave and I married right before our last year of college, and we planned to work on our careers—his as a computer programmer and mine as a teacher—for a few years before having children. (There's a Yiddish proverb that says "We plan, God laughs." Amen. We're not Jewish, but the saying is apropos.) I was in my last quarter of college, commuting half an hour each way to my student-teaching assignment, when the tiredness I'd felt through the winter strengthened into a crushing fatigue. The minute I walked through the door of our tiny one-bedroom apartment, I'd collapse on the couch and sleep, unable to make it to the bed. Dave would make dinner, I'd wake just long enough to eat, and then he'd help me into bed where I was out for the night. *Was I pregnant?* While we hadn't planned for this timing, secretly I was hopeful. But no, my monthly cycle confirmed it was not to be. If I wasn't pregnant, what was it?

We worried enough to find and visit a doctor near the college. His body language screamed that we were wasting his time, but he reluctantly agreed to order a few tests. The next day, when I opened the door to the apartment, Dave intercepted me on my route to the couch, helped me walk the extra five feet to the answering machine, and stood with me as I listened to the nurse talking about my blood test results. Apparently, there was something going on with my kidneys, and the doctor wanted me to go to the city where I was teaching to see a specialist.

Kidneys? What do kidneys even do? Where are they exactly? What does this mean?

The tired old nephrologist we saw in the city had long ago lost his ability to connect with the emotions of his patients. He read my chart, looked at my urine sample under a microscope, and sat down across from us newlyweds. "It's what I thought. Your kidneys are failing. You need a kidney transplant. Do you have anyone in your family who can donate a kidney?" he asked matter-of-factly, as though he was advising us to change the oil in our car regularly. "If we don't find a match, we'll put you on dialysis until we find a donor." Then came the kicker. "Until you get a new kidney, you should not get pregnant." His flat words transformed themselves inside my head. *You will never, ever, be able to have a baby.*

Devastated, we trudged back home, carrying a load of pamphlets that were weighing down our pockets and our hearts. New vocabulary bounced around our heads, creeping into our everyday conversation. Renal failure. Dialysis. BUN, or blood urea nitrogen. Creatinine. Hematocrit. We tried to talk about what the next few weeks or months would look like. We did not talk about the Big Question hovering over us like black clouds. *Am I going to die?*

With nine weeks to go until graduation, I woke up every morning to vomit. Each morning seemed worse than the day before, and it was. My blood urea nitrogen levels continued to rise, and with it, so did my nausea. I dug deep inside myself and found the strength to complete the student teaching with as much integrity as I could muster. It was the last requirement for my degree. Graduation came as both a relief and a personal victory.

We moved to the Big City so Dave could start a Big New Job with his Big New Degree. I was far too sick to look for work. My Big Job was to find a new nephrologist. After the last one, I was nervous. This time, though, I met the finest doctor ever to walk the earth. He was kind, knowledgeable, involved in the region's kidney community, a leader in research, gentle, genuine, and compassionate. He explained what was happening to me in a way I could understand. And he told me it *might* be possible for me to have a baby once I had a transplant. He encouraged me to *believe* that I would feel healthy again, and I took his advice to heart, holding on to the possibility that I would become a mother.

Someday.

I suffered for five years through fatigue, the restrictive lifestyle that dialysis requires, the joy and exhilaration of a kidney transplant, the disappointment and desolation of the transplant rejection, the sense of failure, the pain of surgery to remove the transplanted kidney, the fatigue and illness because of kidney failure, and resuming dialysis. The dream of having a baby kept me going through all of it. I visualized my body with a functioning kidney, and I believed I could become healthy enough to get pregnant and have a family.

Dave and I plowed through this period of our lives in solidarity. With mortality staring us in the face, even though we were only in our twenties, the gift was the

ability for each of us to name precisely what we most wanted from life.

Dave wanted me to live.

I wanted to be a mother.

I fixated on that someday baby.

PREMATURE JOY

t age twenty-six, in 1994, I received the gift of life in the form of a second kidney from an anonymous donor. Per my doctors' advice, I patiently waited through the next year before trying to get pregnant. Well, maybe patient isn't quite the right word. Heavy sighs, whining, crying at the sight of every baby in a TV commercial . . . I was as patient as a child left alone outside the candy store watching everyone else inside.

Dave desperately wanted to be there when I conducted the home pregnancy test. But the windowless bathroom of our first tiny house was too small for two adults to occupy comfortably. The maneuvers required to accomplish any task required the flexibility of a gymnast from Cirque de Soleil. I could not perform *this* task under *those* circumstances with him in the bathroom with me unless he climbed inside the washing machine that was also crammed in the room. I peed on the stick and Dave stood in the doorway holding the timer. *Would the stick show the solid line for 'not pregnant'? Or the cross for 'pregnant'?* The timer beeped. Deep breath. I held the stick out for him to see. We looked at each other.

We held each other, and we both cried. It hardly seemed possible. We had been married for nearly seven years and had faced illness and death. We had grieved over lost dreams. A pile of medical bills buried us so deeply we couldn't conceive of ever digging out. But now? The best thing in the world was happening. All our worries and cares washed away in that moment. We would finally become parents.

My health history predicted a premature delivery, with possible negative health complications for me. We quickly learned that preterm birth comes with many risks to the baby, depending on how early I deliver the baby. We learned that risks for the baby included temperature dysregulation, breathing issues, or liver problems. I understood that I would deliver my baby in the hospital with all the bells and whistles they have. I knew that preterm babies are sometimes whisked away to the Neonatal Intensive Care Unit (NICU) for emergency care. I knew that preemie babies can be kept in the NICU for days, weeks, or even months before they are healthy enough to go home.

I did my best to prepare myself to accept the outcome.
I was ready. Or so I thought.

I was at home when my water broke. One day earlier and they would have called it seven weeks early. A heavy January rain pounded a chaotic drumbeat on the roof of the car as I stepped out to walk across the street to the hospital. A burst of cold rushed up from my feet, sending a shiver through my body. I looked down to discover I had stepped into a torrent of icy water running from the gutter. Hot mixed with cold as more amniotic fluid gushed out, adding to the roaring wet current flowing over

my feet. Walking into the emergency room with soaked feet and pant legs, dripping hair, a spot that looked like I'd had a potty accident, and a distraught-looking Dave holding my hand, I'm sure we were a pitiful sight.

It didn't take long for my blood pressure to go up, up again, and then up some more. Quickly, the cadre of nurses wired me with an IV, a blood pressure monitor, and —inserted through my dilated cervix—a heart monitor attached to the baby's head. The anesthesiologist injected an epidural block to lower my blood pressure. Tethered to beeping monitors and blinded by bright lights, strangers poked and prodded. Something was off with the blood pressure monitor, which kept squeezing my arm so hard the pain rivalled the labor contractions.

This was not the sort of labor where I could drape myself over a ball, take walks to relieve the pressure, or turn down the lights and listen to soothing music while relaxing in a hot bath. There was no quiet solitude in the lead up to the ultimate moment of birth. I tried not to think too much about the fact that this labor, my labor, was fraught with probable danger and risk. The medical team worked to keep me healthy and to bring the baby into the world with the best possible outcome. But, as the hours passed, doubt crept into my mind. What if my baby turned out to be really sick? What if Dave and I couldn't care for it?

I realized I wasn't nearly as ready for this as I'd thought, but it was a little late to do anything about it.

After four hours of beeps and sweat and bright lights and pushing, just as the clock had turned the corner to the new day, our four-pound, eleven-ounce baby boy burst into the world. He was breathing, crying, and seemed in good shape considering he was nearly seven weeks early. The delivery room nurses washed him right there, wrapped him in a blanket, and handed him to his daddy.

Relief washed over me. My baby was okay. Daddy held my precious boy close for me to see, but not touch. As the professionals whisked our newly named Matthew away to the NICU, for some basic neonatal care, I realized I hadn't yet held my new baby.

My dad walked in the next morning sporting a wide grin. He'd held his first grandchild earlier that morning. My mom had a cold and needed to stay away for a few days—not what a first-time grandma wants to do, but the right thing. When I asked Dave how our son was, he happily reported that he'd been able to hold and rock Matthew in his arms and sing him his first lullaby.

It seemed like it would finally be my turn to hold my new son. A nurse offered to take me to the NICU to see Matthew. She bundled me up, settled me into a wheel-chair, and rolled me to the hospital's other wing. With Dave at my side, we entered a dark and hushed world where you wash your hands with the vigor and care of a surgeon. There were chest-high transparent plastic boxes draped with baby-themed blankets. I spotted the incuba-tor, covered by a familiar pale green quilt with appliquéd puppies made by my mom, and knew that under that blanket I would find my baby. Under the watchful eyes of my nurse and the neonatal nurse, Dave explained what he had learned about the tiny blindfold fastened with Velcro around Matthew's little face. "You see that light over him? That's helping his liver function. I guess a lot of premature babies have a problem with that. The blindfold protects his eyes."

I hadn't yet touched my son, sprawled out like a frog on his tummy. All he wore, besides the sleep mask, was the tiniest blood-pressure cuff I had ever seen and a diaper that looked as if it belonged on a child's doll. As I reached for Matthew, Dave moved to open the incubator, a skill he learned earlier that morning.

"What are you doing?" the neonatal nurse hissed, sounding more like a scolding teacher than I ever had in any classroom. Apparently, we had crossed a line. "The baby has already been held for over ten minutes today. You can't just take him out and hold him whenever you want to, unless you want him to get sicker."

What? I still can't hold my baby? With postpartum hormones pulsing through my veins, my face fell. The tears came. Just drops at first, and then a rushing stream down my cheeks.

My nurse quickly whisked us away so I could get myself together in private. Once back in my room, she kneeled in front of me. "I'm so sorry the other nurse spoke to you like that," she said, taking my hands in hers and looking directly into my red and swollen face. "This is not how we usually do things around here. I will call the NICU later and arrange a visit so you can hold your baby."

Later the same morning, a social worker came by and invited us to join a support group for parents of preemie babies. *Hey, we're parents now! Sure, we can do that!*

There was a meeting that afternoon. The leader asked us to be the first couple to introduce ourselves to the group, because we were the newest members or because we seemed so enthused to be there. With an enormous smile on my face, I eagerly gave our names and proudly pronounced, "We just had a baby boy last night!" My smile faded as I looked at the other five couples clutching tissues, staring back at me with pained faces and sniffles.

"There can be different perspectives to the experience of having a premature baby," the social worker leaned forward, empathy all over her face. "Some people are excited because it *is* a birth. Others are frightened of what it means to have a preemie."

Oh, my goodness. I had avoided birthing classes

because I knew I would have a high-risk delivery. I was elated I had given birth to a living child who would soon go home. It hadn't occurred to me I would sit with a group of new parents who had expected a *normal* birth experience and were now facing a crisis for which they were entirely unprepared.

A switch flipped in my brain, thanks again to the post-partum hormones. Suddenly, I felt as though my enthusiasm was inappropriate given my situation. I had things all wrong. *My baby isn't okay. He is too sick for me to hold. I don't know how to care for him. The baby isn't really mine—the professionals are in charge.* These extreme thoughts rooted themselves in my mind, growing into a pervasive pattern of thinking where I believed that I wasn't qualified or good enough to be Matthew's mother.

My nurse finally placed Matthew in my arms later that day. It had been a long journey, but now I could kiss his head, smell his neck, and share my warmth with him. The time they permitted us to spend together each day stretched as Matthew got stronger and healthier. I fed him from a tiny bottle that looked like it belonged to a Cabbage Patch doll rather than a real, live, human baby.

After three days, my doctor announced I was ready to go home. With years of experience being admitted to and discharged from hospitals, I blurted, "Yeah! I can't wait to sleep in my own bed!" A confused shadow passed over the doctor's face before he composed himself. I didn't pay any attention. In my head, I was already packing and planning my arrival back home. Five minutes after Dave loaded me into the car, we were merging onto the freeway, and the significance of what was happening hit me. *I'm going home without my baby.* I sobbed the rest of the way home. Dave drove on, unable to understand what, exactly, was wrong with me. Surely I had understood we would leave the baby

at the hospital, just as Dave had been doing for the last few nights?

The following week we spent our days at the hospital with Matthew and our nights at home, exhausted. Once Matthew was released from the NICU and moved into a regular pediatric room, I moved in with him. When doctors cleared him to go home, eleven days after his birth, I was thrilled. *Yeah! We are all going home together! We can finally start this new life on our own. We are ready.*

But we weren't.

AN HOUR AN OUNCE

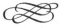

*T*his baby didn't sleep. Seriously. Because my antirejection, immune-suppressant medications were toxic to infants, breastfeeding was out. Bottle-feeding formula was in. Matthew would work for about an hour to consume an ounce or two of formula, and then, exhausted from trying to eat, he would nod off to sleep. I would gently lay him down and try to get some sleep myself. Within half an hour, he'd wake hungry again and start screaming. We'd spend another hour working on another one to two ounces of formula. We did this around the clock for three months.

I'm not exaggerating.

One afternoon, at a get-together with other new and soon-to-be moms, one woman tentatively voiced her most pressing concern. "How do you manage without sleep? I really, really need my sleep. I don't think I can make it if I don't get sleep."

Ever the helpful one, I seized the opportunity to prepare her for the sleep deprivation marathon that was coming. I perched on the edge of my chair, looked her straight in the eyes, lowered my voice, and told her

harrowing stories of the consecutive nights when the baby wouldn't sleep or would let you just get to sleep only to wake you minutes later with a jolt. The mother of three-month-old twins who were quietly nursing, each on their own breast, chimed in with her smug, peaceful smile, "Oh, it's not really that bad."

Not. That. Bad?

Okay. Message received. Apparently, I'm either complaining or exaggerating. Perhaps I was. Or I was going crazy. Or, I just didn't know how to take care of a baby the right way.

One night, sleep deprivation caused me to hallucinate. I was convinced there was a visitor in the room with us. I was aware enough to understand that this wasn't really happening, but I also knew that I had crossed a line. I needed to care for myself to take care of Matthew. You know, the same drill the airlines use, put your oxygen mask on first. I put Matthew in his crib and for the first time let him cry. I woke Dave to tell him he was on duty, and I fell asleep.

That's what it took for me to get going again. I had to go on strike and get enough sleep, at least for one night. This new self-care awareness meant another change, too. During the day, I handed off this fussy baby to anyone willing to hold him.

I needed help, but I was afraid to let anyone know how poorly I was doing. Being a mother was everything I had ever wanted to be and everything I had fought for when things were tough. I feared I was failing. At every turn, people were telling me these were *the best days,* and they were *exciting times.* According to other mothers, it wasn't really that bad, or at least it wasn't supposed to be. I was miserable, my baby was miserable. All the books I was reading talked about the joys of bonding with the baby, as though all mothers experience it. Whatever

bonding was, I was sure what Matthew and I were going through wasn't it. Matthew was an infant who didn't follow the plan outlined in my dog-eared and well-worn copy of *What to Expect When You're Expecting* book. He didn't respond to my efforts to soothe him. My frustration became disappointment and settled into a general sense of dissatisfaction. In my mind I carried an irrational fear that if other people knew how I really felt, they'd take my baby away. Despite my misery, I couldn't bear the thought of being separated from my baby.

The Thursday before my first Mother's Day, I was enjoying a few precious moments of midmorning sleep when the ringing phone woke me up. It was Dave. "I just got laid off. I have to pack my stuff, and there's a guy here waiting to escort me to my car."

My mouth said, "Oh my gosh, I'm so sorry, what happened? Are you okay?" My heart said, "Oh thank God, now you can help me with the baby!" That's how low I had sunk: even the financial uncertainty of unemployment couldn't be worse than dealing with a perpetually unhappy baby and no sleep. While Dave searched for a new job, he helped me gain some balance with the workload at home.

As Matthew began to mature, his eating and sleeping fell into a pattern I could measure in hours rather than minutes. Eventually, an identifiable nap time emerged, which gave me a sense of control over our routine. My confidence as a mother grew.

Dave landed a new job at the end of that month. Taking the job meant we had to move from the city.

Thus began life in a small rural town, where every day dawned with the opportunity to be the mother I'd aspired to be.

TOUGHEN UP, BUTTERCUP

I thought my teaching certificate made me an expert on children, but my real apprenticeship had only just begun.

I was determined to be a stay-at-home mom as long as possible, embracing every moment with this child we had finally received. I like kids; I enjoy doing kid stuff; I enjoy watching kids grow through all of their life stages. I enjoy teaching kids how to explore new things. Kids can make me laugh or smile at just the right moment.

Matthew grew into his toddler years, and I grew into my role as a mother. I step-aerobicized my way to a sixty-pound weight loss and a healthy body while Matthew made friends at the gym's daycare.

I was filling my scrapbooks with captured memories—magical moments. There's a picture of three-year-old Matthew clapping his hands in delight while at the kitchen table with his stuffed Elmo, Cookie Monster, Big Bird, and Oscar surrounding a cake and a pile of misshapen lumps covered in birthday wrap.

No, it wasn't Matthew's birthday. We had tired of the television, the toys, the dog, and each other. Matthew's

boredom devolved into meltdowns, and mine dissolved into tears. I finally coaxed Matthew into a nap and I knew that while he slept, I had to think of something.

When Matthew awoke, I whispered, "Today is Elmo's birthday, did you know that?" Under beautiful long eyelashes, his eyes grew wide. A smile slowly dawned as he whispered back, "No."

"Do you think we should have a birthday party for him?" I prompted, having already checked the pantry for cake mix, frosting, and birthday candles.

"Uh-huh."

"Well, what do we need for a birthday party?"

"Um, cake?"

Exactly. And making a cake is at least an hour-long project. At least it is with a three-year-old.

"Okay, do you want to make a birthday cake for Elmo with me?"

"Yeah!" Matthew was now fully engaged.

I set the cake on a rack to cool beside the can of chocolate frosting.

"What about presents? Do you think Elmo will like presents at his party?" I wanted to stave off any hint of boredom before it could sneak back in.

"Uh-huh . . ." I could see Matthew wasn't sure where this was going.

"What if you picked some of your toys and we wrapped them in birthday paper?"

"Okay!" he yelled, rushing to his toy box.

"Maybe you could just choose three or four."

Thirty minutes later, thanks to a stockpile of just-in-case birthday wrap and a roll of tape, Matthew piled four mummified lumps on the table.

"Who should come to Elmo's party? We should make invitations." I said, digging through the stationery drawer for notecards. I wrote the words, Matthew drew pictures,

and together we delivered the invitations to the living room. Then we returned to the kitchen. Matthew clambered onto the chair I'd pulled close to the counter and we applied the frosting, even getting some on the cake. We added birthday candles, sang the happy birthday song, and Matthew helped Elmo open the presents, we ate cake, and soon it was time for Elmo and friends to go home. Afternoon had morphed into early evening and it was time for me to prepare dinner. Dave arrived home surprised to find a partially eaten birthday cake on the counter as he listened to Matthew tell him all about Emo's birthday party.

The Gibbs family scrapbooks are brimming with stories. Matthew standing in the snow, his hands held high with an "I-don't-want-to-touch-it" gesture. Matthew trying to catch cold water pouring out from a downspout during a spring rainstorm. Matthew's head poking out from under a sand dune, the rest of his body buried under a warm and heavy sun-drenched blanket of sand. Matthew smiling his biggest grin, standing on a kitchen chair with my apron tied twice around his waist, turning the crank of the apple peeler over and over and over again while I made gallons of applesauce. Sitting at the dinner table with no shirt because it was spaghetti night, and that always morphed into a finger painting full-body experience. Matthew on his tiptoes, reaching as far as he could to turn on or off a light switch, often actually on and off in rapid succession.

My intention was for the pictures to capture and celebrate the funny little quirks of our cute little boy. They were also windows into what life was like for Matthew. The snow didn't feel good (probably too cold); the running water felt good (but it was so cold); the sand was warm and soft against his skin and enveloped his entire body with pressure; the repetitive action of turning the

apple peeler crank for hours on end was soothing. We learned that when Matthew turned all the lights in the house off, then on, and then off again, he was feeling tired, hungry, or some other distress, and a meltdown was on the horizon. The clock was ticking. It was a race against time, only we had no idea how long we had from the moment of discovery. We had to find the source of the distress and resolve it before a meltdown ensued.

You win some and you lose some.

We were learning Matthew's idiosyncrasies, but we didn't understand why they existed. There was an undercurrent in our life that flowed differently than for the majority, leaving me feeling isolated and bereft.

I believed that I was doing all the right things to help Matthew grow socially, intellectually, and creatively. We spent days at the park, made play dough sculptures, and went bowling. But he rarely enjoyed these things. Yet, he loved to listen to me read from his prized book about the solar system and draw pictures of the planets. I encouraged that, and secretly felt a little pride at what I thought might be a sign of a prodigy, but I also wanted to know that Matthew would meet the typical milestones he would need to be successful when entering school. Matthew's atypical development was a source of deep concern for me, but as to the extent or the cause, I was in denial, blaming myself for not doing something, anything, right.

As a toddler, Matthew's version of playing with his toys looked something like this: go to the toy box in the living room, pull out a toy, carry it a few feet, drop it, do something else for a few minutes (like stare into space, laugh at the dog, chase the dog, pat his shadow on the wall, tear wallpaper off the wall), go back to the toy box and find a new toy to carry another few feet before dropping it. Wash, rinse, repeat. He'd never actually play with his toys, just spread them around on the floor. I spent a lot

of time putting toys back in the toy box. When advertisements for baby toys came on TV, I'd think *what a marketing hoax. Babies don't really play with that stuff. They're just playing into adult's sentimentality.* A conclusion from my vast experience of parenting one child.

Story time, when he sat on my lap, was my Trojan Horse for snuggles. It was the only time he wouldn't wriggle out of my arms or run away when I tried to express physical affection. Matthew's response to sensory input was straining my relationship with him. I would later learn that for him, a touch—even a cuddle or a hug—felt like sandpaper rubbing on his skin or an electrical jolt.

The days exhausted me, but I dreaded the nights. Nighttime was a ghoul overshadowing my existence. The baby who couldn't sleep or self-comfort grew into a toddler who would scream from night terrors. For years, Dave and I snatched sleep in increments of a few hours, in between the sudden and violent high-pitched screaming from the next room. The challenge was to calm our over-whelmed and confused child without stroking his head, rubbing his back, or rocking him back to sleep. My instinctive maternal strategies caused my child more discomfort.

Matthew's response to pain was uniform. All injuries elicited the same screaming response. One evening, while we were at Dave's church-league softball practice, I heard Matthew screaming and turned to see two older kids escorting him to the bleachers where I sat. I climbed down to the bottom row to meet them. Unable to speak through the screams, Matthew held up his hand. I checked for the mortal injury. There was no blood, all the fingers could bend, everything was moving, and there were no scratches. Nothing visible at all. I pressed Matthew's hand between mine, wiped his face, gave his hand a kiss, and sent him

off to play. He left, still wailing loud enough for those in the next town to hear. Other parents were watching me with their mouths hanging open. One mother voiced the question I imagined was on all their minds. "Do you think he might be really hurting?"

Heavy sigh, deep breath. I dug further to find a calm, monotone voice and put it out there for the collective. "His reaction is the same for a hangnail as for a broken finger." Not only did I seem like the worst mother in the world for behaving as if I didn't care that my child was in so much pain that he might need emergency services, but I wasn't even cuddling him to calm him down. What these other parents didn't know was that if I had tried to cuddle him, his reaction would only have escalated.

My sense of failure as a mother deepened as the reality set in that I had no idea how to help my son. My inability to comfort him weighed heavily on me as a closely guarded secret. I kept up the outward appearance of the mom I had always wanted to be: The one who organized playdates, made special birthday cakes, played in the snow, went to the beach, made home-cooked applesauce, planned camping trips, and organized the Christmas play. I sunk every ounce of energy I had into trying to enjoy those times. But I was so tired. Chronic sleep deprivation was draining my enthusiasm. Matthew's high energy and brief attention span exceeded my capacity for daily activity.

Occasionally, I would drop hints about what was really going on in the background of our life. "When your kids were little, how did you manage to do . . . when you'd been up most of the night?" But the perplexed look staring back at me said enough for me to redirect the conversation away from this failure of mine.

I was honest with Matthew's doctor about his sleep and behavior issues. "Lots of children meet milestones at

different times," she reassured me. Which transformed in my head to, *toughen up, buttercup.*

Despite surrounding myself with other moms and other children in playgroups and filling my days with meaningful activities, I still felt alone. I couldn't help Matthew get the sleep he needed. I couldn't comfort Matthew when he was hurt. I couldn't get Matthew to settle down long enough to engage in productive or interactive play. And I didn't understand how the world felt to him.

When Matthew was three and a half years old, his sister Anna was born. Whereas Matthew came into this world fighting for survival, struggling to eat, unable to sleep for long stretches, Anna joined us with her eyes open, seeming to say, "Hello! I'm here! What shall we do now?" When she was hungry, she'd let out a noise like a kitten's mew, and once satisfied, she'd sleep for hours. It was clear she found comfort in my arms.

It turned out that I did know how to be a mother after all, and under the right circumstances, I was quite good at it. Maybe, just maybe, my lack of maternal skill wasn't the cause of the struggles that Matthew and I had been living through.

A SERIOUS CALLING

*B*ecoming a mother changed me, infusing me with a sense of awe and purpose unlike anything I had ever experienced before. It became my mission, my life's work, to mold Matthew and Anna into adults who were happy, healthy, and whole. This was a serious calling.

We're Roman Catholic, and we opted to present Matthew for baptism back when he was three months old. We sat with five other couples, our new infants nestled in their car seat carriers, eagerly anticipating the start of the preparation sessions for our children's upcoming baptisms. The group leader interrupted our quiet small talk and asked that we introduce ourselves to the group. Next she said, "God has blessed you with this amazing new child. Close your eyes and think for a moment. What are your hopes and dreams for this child?" After a few quiet moments, letting us reflect on our answers, she spoke again. "When you open your eyes, I'd like you to write these hopes and dreams for your baby. I have paper, pencils, and crayons if you prefer to draw your response instead." I wrote, "Dear Baby Matthew, all I want for you

is to grow up loving God, loving your family, and loving yourself."

That sentence was my compass for the next twenty years as we journeyed through the fun, the conflict, the silliness, the stress, the surprises, the disappointments, and the messiness of family life. But hopes and dreams alone aren't enough to make things happen. It was imperative to teach my children *how* to love God, *how* to love their family, and *how* to love themselves.

Dave and I deliberately integrated our faith in God and our involvement within the church community as the center of our family life. As young children, Matthew and Anna were at our sides, and sometimes right under our feet, serving monthly breakfasts to parishioners, bringing dinner to sick friends and strangers, sharing in soup suppers in the church basement on Wednesday nights during Lent, and singing in the choir every Saturday night. They attended Sunday School classes and Vacation Bible School, and as they grew older, they became teen leaders of the Vacation Bible School, played instruments with the choir, and served at mass.

Wonderful people added a warm color to our experience. We blended into a community of friends who welcomed us into their fold, who were uncritical of Matthew's need to *move* even when the cultural norms of mass expect a quiet stillness, and who encouraged us through the stages of our lives.

Some of these people showed the true devotion of their friendship on the day of Anna's baptism. It was a hot, dusty August day when our church-league softball team, after ten years of thwarted attempts, finally made it to the final round of playoffs. Anna's godparents were on the team, and we invited every single player to come to mass and then a reception at our home. A light rain had fallen during the previous game, and the teams had an hour to

wait before the final game would begin at four o'clock in the afternoon. Covered with dust and sweat from a full day of softball, now turning to rivulets of brown dripping from their hair as they watched the field slowly turn to mud, they had a decision to make. Anna's Baptism Mass was at five-thirty, and everyone would need a shower before arriving. Could they play the game and still make it?

They forfeited the game. They chose us.

We prayed at home—always at meals, often tagging our own personal prayers to the end of grace, "And thank you God for my new Pokemon game. Amen." We wove rituals and traditions into our routines, inspired by the seasonal traditions of the church. The four weeks before Christmas marked the season of Advent, and my hand-made Advent Wreath glowed with its three purple and one pink candle as we prayed before dinner each night of those weeks. We put one shoe on the porch on St. Nicholas Day, December 6, to discover chocolate marshmallow Santas in them later that night. On December 13, St. Lucy's Day, a commemoration loosely based on a Scandinavian tradition, we would eat dinner by the light of a dozen tea light candles and enjoy cinnamon rolls as dessert. For dinners on Fridays during Lent, we would often join friends at the church fish fry followed by prayer time at the Stations of the Cross or just stay home with a meatless meal.

Dave and I also established some new traditions unique to our family in our efforts to develop and deepen the kids' connection to the rich traditions of our ancient church. Matthew had been baptized in April, and Anna in August, and we reflected on the significance of baptism on each of their baptism anniversaries by inviting their grandparents and godparents over to eat cake, re-light their baptismal candle, sing the song that we sang as they were each baptized, and watch the videos of their baptisms. The

child who we were celebrating as a Child of God would eat their cake off of our It's Your Special Day plate.

The family tradition that we all treasured the most is entirely our own, derived from religious and cultural traditions around the world. We celebrated the twelve days of Christmas by collecting and wrapping twelve gifts for each other with a $12 budget. Each night following Christmas, we would open one gift. On the twelfth night, we'd open one larger family gift to celebrate Epiphany, also known as Twelfth Night or Three Kings Day.

One evening in November, when Matthew was four and Anna was one, Dave arrived home late from work to find me a little cross because the kids and I were hungry, the green beans were soggy, and the meatloaf was drying out in the oven. Properly chastised and with lowered eyes, he apologetically offered me the bag in his hand. Inside was a bag of treasures he had bought from a craft store on his way home. There were four canvas tote bags and an assortment of fabric paint. These were to be our Twelve Days of Christmas bags, in which we would each have our twelve wrapped gifts in our own bags every year. Feeling guilty for my not-so-welcome homecoming, I hugged Dave and thanked him for his thoughtfulness. Once we ate dinner and washed the dishes, we spread newspaper over the table and painted our bags. Anna got help from her daddy and her bag showcased a lovely picture of Mary, Joseph and Baby Jesus, with a star shining in the sky. Matthew covered his bag with a fabulous painting of the solar system. Nothing says Christmas quite like the solar system.

Even today, at the end of Christmas Day, those four canvas bags are stuffed with gifts and the one solitary wrapped gift left under our tree, leaving us with a sense of anticipation that there is still more excitement to come. Tapping into the art of motivation and efficiency, I estab-

lished a routine to the Twelve Days ritual. For each of the twelve nights, after dinner, it requires each of us to write one thank you note for a Christmas gift before we choose a gift from our bag. We don't know any other families who do anything like this, but each one of us holds this tradition close to our hearts. It's fun, and it belongs uniquely to us.

Dave and I deeply appreciate the church's practice of solemn reflection on what it means to encounter God during the Advent season, specifically manifest in keeping the church building bare of decoration except for an Advent Wreath. But when we arrive to celebrate the arrival of God incarnate at Christmas Mass, the church is awash in bright lights, flowers, a nativity scene, and the sweet chords of Christmas hymns envelop us all. It's a special celebration that begins at Christmas and ends twelve days later. Wanting to embrace the spirit of the church's message and model its value for our children, we blended church and secular traditions in our home by only setting out the Advent Wreath and the Advent Calendar for the first week. Anticipation built as a new piece of the Christmas décor emerged each week after that. We strung the outdoor lights over the following weekend, then arranged the nativity set on the mantle for the third week, and finally we placed the Christmas dishes in the cupboard. December 24th was our big day to finish the preparations. We set up the tree, strung it with lights, hung wreaths, and set the table for the extended family's Christmas dinner the next day. Arriving home after the early Christmas Eve Mass, we drank hot cocoa, ate cookies, hung ornaments on the tree, placed our brightly wrapped presents under the tree, and hung our stockings. Every year I heard the same question from well-meaning friends, "Don't the kids want the tree before Christmas?"

"No, we love the way we do things, and honestly,

when Matthew is inundated with so much stimulation in the run up to Christmas, it just seems to make him more agitated. Doing it this way seems a win-win all around."

Church and community and our own family traditions became the tools I used to express my purpose as a mother.

I embraced the responsibility with reverence.

SPILLED MILK

One brilliantly sunny morning in March 2001, nearly two years after Anna's birth, Anna and I went to pick up Matthew from his morning preschool, six blocks away. On our way home, I noticed a for sale sign had sprouted overnight in front of one of my favorite houses, and there was an open house. On impulse, or curiosity, or perhaps a little of both, I stopped in for a tour with both children in tow.

I fell in love with this house. It was everything I'd ever dreamed of. It was old (built in 1916) but had great potential for decorating (antiques anyone?). It needed some light remodeling, which we liked to do (on a do-it-yourself budget), and it had a beautiful yard blooming with a smattering of bright yellow daffodils.

It took a while to negotiate the buying and selling of our homes, but by Thanksgiving we moved into that house two blocks up the street from the one we had called home for the last five years. Matthew had started kindergarten by then, but this move didn't involve any big changes like moving to a new school, a new church, a new

neighborhood, or even meeting new people. Other than the physical work of packing and unpacking a household with two young children around, this wasn't really that big a deal.

How wrong I was.

Matthew had just begun school two months earlier. For him, each day was an onslaught of loud noises, bright lights, and people asking questions he didn't know how to answer—questions like "How are you?" There were rules he didn't know how to follow, and there were people everywhere, all the time. He had also begun Sunday School at church. Here, too, were new adults who asked questions and talked loudly. Teachers expected him to sit for long periods when his body needed to wiggle. On top of all of this, he had a new bedroom in a new house. The light was different, it was colder, there were stairs, and it smelled different. His brain was at maximum capacity for dealing with change.

The Friday after we moved, Matthew was having an after-school snack when he spilled his milk and had a screaming meltdown. Yes, he was literally crying over spilled milk—not an uncommon occurrence in our household. I did what I had learned to do with meltdowns by that point and calmly asked him to help me clean it up. Usually, if I assigned Matthew a specific task, he could regroup and calm himself relatively quickly. However, on this occasion, he was too emotional (stressed) to stop screaming. He was also hitting himself and repeatedly calling himself "stupid." Taking a deep calming breath, I quietly told him to go upstairs to his room until he felt better. This had worked for us before, in the old house, and I was hoping he would settle in his own space.

He went up to his room, but instead of soothing himself by playing with his Legos or Matchbox cars, he took nearly two hundred books off the shelves, books I

had just unpacked and put away that morning, and threw them on the floor. From where I stood, directly below his bedroom, I watched the dining room ceiling shake and listened to the ka-thump, ka-thump from above.

I walked out of the room, away from Anna's eyes and ears, to the enclosed back porch, where I choked on gut-wrenching sobs. "Please help me," I pleaded with God. "I can't take this anymore."

It was my bi-weekly Friday night scrapbooking workshop. But I was emotionally drained, and I didn't want to go. I just wanted to clean up Matthew's books and go to bed. But Dave insisted I go, knowing these scrapbook workshops provided an important social and creative outlet for me as much as they gave me time out of the house on my own. He also volunteered to help Matthew put his books away before I came home. I pulled myself together, wiped away the tears, and continued on with my duties as the family's homemaker. I made dinner, cleaned up, and left the house.

A new person joined our group that night, so the rest of us regulars kept the conversation a little lighter and less personal than usual. After an hour, one of my friends innocently asked me, "How's it going with the move?" Trying to keep things light, I offered a vague answer about how I love the house, but that Matthew had a tough afternoon. The group had heard enough stories about life with Matthew to know that my tone was code for *I don't really want to get into it right now.*

The newbie with the curly red hair turned her focus on me. She wanted to know what happened. I gave her a glossed over version of the afternoon's events. She asked increasingly specific questions about Matthew. Did he focus a lot on one thing? Was he uncoordinated? Did he throw temper tantrums? Did he avoid human contact?

Stunned by her ability to pinpoint the precise flash-

points of my life with Matthew, I opened up and answered her questions in increasingly more detail.

I told her how, early in Matthew's childhood, I knew he was developing differently compared to other children. It wasn't exactly a developmental delay, where a child takes longer to achieve benchmark skills in the same order as typical kids (like sitting up, crawling, then standing, then walking). Matthew was on a path of what I came to call alternative development, where he reached developmental milestones out of order.

Because Matthew was our first child, I didn't know he had skipped one hallmark of typical childhood play. Anna was three years old when I heard her talking to Matthew in the upstairs hall outside of their bedrooms.

"You be the cat, I be the dog," little Anna directed. There was a pause before I heard her say, "You go like this. Say meow, meow."

I smiled, imagining the scene. Then I heard growling in a deep voice, more like you'd hear from a bear. "Meeooww . . . meeoww." Anna laughed. "I chase you!" Dishes rattled on the plate rail as the thump, thump, thump passed overhead.

As cute as this scenario was, I felt slightly discomfited by it. As I shared the story with my new scrapbooking friend, I realized what was bothering me. Matthew was six years old, but he had never played pretend. He needed his three-year-old sister to teach him how to do it.

Matthew was coordinated enough to read music and play the piano, but he couldn't hold a pencil well enough to write. Having a conversation with him meant that you listened to him talk at you about whatever facts he was interested in at the time (the solar system, Pokémon, the periodic table) without getting a word in edge-wise. There was the teacher who reported that Matthew spent his recess talking to a tree on the playground.

While I relayed the stories the other scrapbooking ladies had heard before, they became silent, averting their eyes from me and this wild-haired woman and shot each other looks of distress. *Who will save Gibbs from this stranger prying into her private life?* They shifted in their chairs and were about to turn away to chat with one another when this woman confidently pronounced that Matthew had a form of autism, probably Asperger's syndrome, or, at the very least, a sensory processing disorder. *How did she know this?* Her sister worked with kids like Matthew.

I walked in the door and had barely set my gear down before rattling off the entire conversation to Dave. Not quite deciphering what I was trying to communicate but thrilled to see the improvement from my earlier mood, Dave humored me and together we dialed up the internet, the only internet service we could afford, and searched on the term I had written down, Asperger's syndrome. We found a checklist of characteristics of people with Asperger's syndrome, and we recognized that Matthew shared thirty-seven of the forty-six traits listed. The likelihood of having Asperger's syndrome increased with every item you checked after the fifteenth.

I wanted to weep with relief. Here it was. An arrow pointing us in a direction, hopefully the right direction. Any clues that might help unlock the mysterious world my son lived in was a gift. God directly answered my desperate cries for help by sending a drop-in scrapbooker to the workshop that night, someone who knew enough about autism to hear the desperation under my bravado, and to show me where to look for help.

That night marked a turning point for me as a mother. In the beginning, I spent my maternal energy trying to nurture a baby who rejected my physical affection. I spent several years dedicating myself to providing a range of

experiences that should have been a source of growth and joy, but Matthew often found overstimulating or confusing. Now, I was gaining more clarity on Matthew's actual needs. Matthew had a disability, and I was determined to teach him how to navigate the world despite that disability. I was a mama bear protecting her cub.

In the early years of this century, the medical community was still building awareness of Asperger's, autism, and sensory integration. It was far more difficult than it is today to find medical professionals who understood and diagnosed these disorders. One professional suggested we could eliminate Matthew's meltdowns by using a sticker chart. Another told us Matthew didn't sleep because we gave his new sister, Anna, too much attention. Yet another told us Matthew would grow out of this *stage*.

Matthew's doctor was reluctant to issue or recommend an Asperger's diagnosis. Instead, she diagnosed him with sensory processing disorder, or as they called it at the time, sensory integration dysfunction. She referred us to a physical therapist who specialized in helping young children with their overstimulated senses learn to navigate the world. The therapy sessions gave us some excellent ideas to help Matthew, like rolling him in a blanket, tight like a burrito, to make him feel calm. It was helpful, but I still didn't feel like we were addressing the full picture. I continued to talk with our pediatrician, and with her help, pursued further medical evaluation.

Eventually, we found doctors who specialized in diagnosing children on the autistic spectrum. At first, they met me with cautious skepticism. Mothers who overreact to children they perceive as under-performing must be regular callers. I answered questionnaires by the dozens, each one asking essentially the same questions in different ways. Finally, with full awareness of our world of night

terrors, nighttime wakefulness, frustration tantrums, hyper-focused interest and play, repeating and mimicking the speech and sounds of others (echolalia), hand flapping, sensitivity to touch, lack of eye contact, and underdeveloped social skills, doctors began to treat me as a credible mother with genuine concerns.

We consulted many doctors over many years and Matthew's diagnoses morphed from sensory processing disorder to Asperger's syndrome to high-functioning autism to possible attention deficit hyperactivity disorder (ADHD) to borderline personality disorder to a possible combination of all the above. If he was going to live a successful and fulfilling life, which I defined as living independently, working, and having healthy relationships, then he would need to learn how to manage his disability. I believed it was my responsibility to teach him how to have meaningful conversations with people, how to organize his time and his work, and how to control his emotions. It became my job to coach Matthew through the process of learning how to become a thriving adult.

At school, there were teachers/counselors/psychologists/administrators who doubted the degree of Matthew's disability and told me that the doctors didn't know what they were talking about. When writing Matthew's individualized education plan (IEP), the school psychologist said, "That diagnosis doesn't really mean anything." When conferencing with his first grade teacher, I listened to her list the ways Matthew could make things difficult in class, especially during times of transition. As I offered a few suggestions, she interrupted me saying, "I've been doing this for a long time. I know what I'm doing. Don't worry. He'll grow out of this."

I recognized that these people had worked with many children over the years, but they had never worked with

Matthew. Matthew was unique and wonderful. Matthew needed his caregivers to use different strategies than they might use with typical children. Rather than value my insight, they labeled me as an overprotective/hysterical mother, and ensured Matthew's school experience was fraught with more conflict than I believed necessary.

I heard from friends, coworkers, and even perfect strangers that I should let natural consequences provide feedback to Matthew when he made mistakes. "That's how children learn," many said. I agreed with this principle—for a typical child, one who would learn from failure, who would examine the experience to understand why it happened, and to ensure it wouldn't happen again. It worked for Anna.

But Matthew was not a typical child. Matthew had an invisible disability that caused him to make unusual mistakes. Like the time, when Matthew was thirteen years old, that the school called to tell me he'd gone outside during passing period, and was repeatedly rolling down the hill, coming back up, rolling down the hill, coming back up, rolling down the hill . . . until a teacher went outside to retrieve him. Matthew could not unpack how the mistake happened or recognize that the events following the mistake (the consequences) were related to the mistake itself. He had no idea how he could avoid making the same mistake again because he didn't understand how his behavior was a problem in the first place. He perceived himself as helpless against the world's external forces. I spent hours during countless sessions with Matthew, talking about mistakes or problems that arose at school. I asked questions that rivaled a prosecuting attorney to glean details about what happened before, during, and after an incident. Once we had pulled the story out, we'd identify the mistakes made along the way

and think of alternative ways he could handle similar situations in the future. I saw myself as his guide. Others saw me as a rescuer.

Matthew came to see me as the enemy.

FAMILY HISTORIAN

*G*rowing up, I knew my parents adored me. My extended family comprised our social life throughout my childhood. My parents gave me opportunities to grow and be just about anything I wanted to be. We were a healthy and happy group of people who loved each other, got along most of the time, knew how to resolve conflict, and most importantly, knew how to forgive one another when we needed to. My parents made it so easy for me to love my family that I assumed it was an effortless thing for a parent to make happen.

Setting out on my quest to ensure that my children love *their* family and emerge as adults with the connection that I have with my own nuclear family, I soon learned that this job requires nerves of steel and the stamina of a workhorse. The first phase of my plan was to demonstrate my love and devotion for my children tangibly, reminding them constantly through both words and behavior how much I cherished them. Thus began the construction of the picture wall.

I became our family's historian by storing and displaying our pictures. And I did it well. I have kept

volumes of photo albums meticulously documenting significant events in each child's life and a set that tells the story of our family, beginning with the first dates where Dave and I went to college dances and played cards in dorm rooms. Frequently, when a family story is being told, I will pull out the corresponding album to find the pictures that accompany the story.

I lovingly placed the first newborn photograph of Matthew in his blue going-home outfit in an eight by ten-inch frame and hung it carefully on an otherwise empty wall in our family room. At three months, six months, nine months and then his first birthday, Matthew and I arrived at the photography studio with Matthew wearing some of his cutest clothes and smiles. We left each visit with a new picture to hang on the picture wall. Every birthday, every team picture, every special celebration at church or school, every Christmas, and every graduation called for a fresh addition to the picture wall. Anna's pictures joined the mix, a few snapshots of our pets made the cut, and there were annual Christmas pictures with Matthew, Anna, and their cousin Ryan, who is a year younger than Anna. A few funny snapshots earned honored space on the picture wall, like the one with Anna and Ryan as toddlers making silly faces, and a poignant one of my dad pushing my mom on our outdoor swing. There is also one of nine-year-old Matthew conducting a complicated science experiment with our friend, a high school science teacher, in his lab.

When we moved up the street in 2001, I christened the hallway outside the upstairs bedrooms and bathroom as The New Picture Wall, with its gemstones sparsely dotting the landscape. This was not a timeline, but a collection of memories and a celebration of love. Nearly fifteen years later, when it was time to move again, the picture wall was a lovely cacophony of orchestrated chaos.

Ceiling to floor, one end of the hall to the other, and down the stairwell. At all ages and stages, Gibbs family members smiled at you. The picture wall benevolently reminded us we belonged here, to each other, every time we passed by.

The family that . . . together stays together. No matter how you fill in that blank, the adage is true. If my intent was for our family to stay together, be a strong and close-knit family long after childhood was over, then we needed to establish positive patterns from the beginning.

The second piece of my plan to hold us together was to lay a strong foundation to our family structure by providing rituals and traditions, some of them faith based and some of them designed more for cementing our family identity.

Until the teenage years descended upon us, my role orchestrating a symphony of family togetherness and bonding was demanding, but enjoyable and rewarding. Dave and I read aloud to our kids every night until they were old enough to finish chapter books on their own without waiting for us. Dave created voices for characters —like Drover from the *Hank the Cow Dog* books—that were so good they were part of the household. As a family, we played board games and card games. We camped three or four times every summer. We slogged through muddy pumpkin patches looking for just the right ones to transform into jack-o'-lanterns for Halloween. We also worked in the yard together. While yard work may not have been the best of times—it was filled with grumbling, arguing, complaining, heavy sighs, and *there are child labor laws in this state you know*—we had a big yard that needed attention nearly every weekend if we wanted to prevent it from becoming over-grown and unkempt, which meant we all had to do our share of the work. Teamwork, persistence, and a few dives

into leaves piled three feet high were part of the glue that held us together.

When the dark storm clouds of Matthew's adolescence rolled in, life became more volatile and keeping our connections and sense of togetherness morphed into what often felt like an exercise in futility.

The pictures of Matthew from those years reflect a change beyond just the change of a boy growing into a man. There are a few that captured his smile, like when he was opening a birthday gift, or enjoying the Halloween bash he and Anna hosted one year. But most of the pictures feature a scowl, furrowed eyebrows, and a vacancy in his eyes. I knew he was miserable. I knew his grades were falling. He was angry with someone in the family (usually me) most of the time. I knew enough to know that these were signs of potential drug use or even being the victim of sexual abuse. I dug deep but found absolutely no evidence of either drugs or alcohol. I dug deeper, trying to find out if anyone had abused him, but I couldn't identify anything.

I continued to capture every family event and milestone with pictures I memorialized in scrapbooks so I could retell the stories again over the years. But, with each passing year, Matthew grew more and more reluctant to have his picture taken, and the few I took were of a very unhappy boy scowling at me. I kept the family traditions going, keeping my spirits artificially high, but eye rolls and indecipherable grumbling were the closest thing to participation Matthew would offer. He rarely agreed to play a game with us anymore. When we went camping, he would lie in his own tent playing solitary games on his Nintendo DS.

I mined the depths of my mind, searching for new and creative ways to hold the family together. I poked fun at myself and started what became a running joke. When my

plans went awry because of poor planning or getting lost, we were "on an adventure." Matthew and Anna jumped on the bandwagon and bonded with each other at my expense by groaning and eye-rolling whenever they heard, "We're on an adventure!"

An adventure indeed.

UNHAPPY BOY, UNHAPPY MAN

*O*nce Matthew entered school, it became a never-ending cycle in which I set goals; he achieved them, and then I set new ones. I'd been at home full time through Matthew's elementary years, and I immersed myself in teaching him the basic skills of self-care; how to get ready for school independently; how to make his own lunch; how to own the responsibility of homework; and how to manage responsible behavior in public.

I had assumed the role as Matthew's coach. I was hyper-focused on the end goal of growing him into an adult who could live independently, work productively, and have healthy relationships. It felt like an insurmountable mountain to climb, but I meted out the journey in incremental steps. Like encouraging him to ask a friend what they wanted to talk about, or to sort his school papers and organize them by subject.

In my mind, the stakes were getting higher with each passing year. Adulthood was on the horizon and there was still so much work to do. Matthew needed to learn to organize his time and his work independently. He needed to connect with the world on a social level and go places

with other people. I couldn't yet see an adult inside the boy, and I felt a frantic urgency to guide him forward. My heart was in the right place, but I'm not sure Matthew benefited in the way I'd intended.

Finally, after eighteen years of delayed career plans, when Matthew went to middle school in the sixth grade, my role as a mother changed once again. I got a job teaching first grade in a bilingual classroom. I became the teacher I had prepared to be. The demands of transitioning to full-time work while being a mother, relearning a job I'd been away from for a long time, and relearning Spanish, a language I hadn't used for many years, was quite a challenge. I didn't have the same time or energy. And it meant it was time for Matthew to do more of the heavy lifting to own the independence he desperately craved.

I was no longer patiently helping him organize his homework assignments before sitting down to complete them every night. I wasn't going through the meticulously detailed process of unpacking every day's incident or problem (to Matthew's great relief). Instead, I was drilling him nightly with questions about what homework he had done and whether he had organized his binder, which often resulted in late nights doing the work he'd ditched earlier in the day. And outbursts, and banging, and slamming.

Matthew's school experience in middle school was far worse than I knew. From the age of twelve, it was a daily barrage of name calling, being spat upon, sexual innuendo, and outright bullying which even extended into stalking and vandalism of our home. This continued through his sophomore year, and I believe was responsible for the darkness overshadowing Matthew's life.

The truth about his life at school was one of his first

big secrets. His other big secret was his, and only his, for at least another six years.

Passing periods were prime opportunities for kids to spit, trip, shove, or hit him without being seen by adults. During the final week of each school year, band students brought their instruments home for the summer. As one particular school year drew to a close, Matthew quietly tried to reach the end of the last week without me noticing that his snare drum hadn't made it to our house.

I noticed.

Apparently, other band mates in the percussion section had slowly dismantled Matthew's drum throughout the year to replace broken parts on their own drums. Soon, Matthew had to use an old drum he found in a back corner of the band room. He was deeply ashamed of his victimization and hoped to avoid having to discuss it by not bringing the battered old drum home. Years later, when I heard this story, I was heartbroken. Especially when I recalled my accusations that he was forgetful and irresponsible.

When he went on to high school, he no longer complained of bullying, and I'd expected this would lead to fewer outbursts at home. Not so.

Matthew was increasingly either combative or withdrawn. When I'd ask, "Have you finished your homework?" he might quietly say, "Yes, I finished it at school." Or, he might fly off the handle with, "WHY ARE YOU NAGGING ME? YOU DON'T TRUST ME WITH ANYTHING!" Then he'd stomp up the stairs, each footfall so heavy the hammers in the back of our upright piano would vibrate, occasionally striking the strings, a discordant soundtrack to the discordant scene. He'd slam his bedroom door hard enough that the chandelier in the dining room, right below his room, would sway back and forth as though we'd been through an earthquake.

Whether it was us asking him to finish up a video game before dinner or pick up his socks from the living room floor, I never knew which response I was about to get.

For years, I used strategies to teach Matthew how to suppress the urge to burst out with disrespectful behavior. I ignored his outbursts. I explained how we felt inadequate when he treated us with disrespect. I applied consequences for inappropriate behavior. I even sent him to a counselor. Discouraged by my failure, I ran out of ideas of how to help him cope with his emotions in a productive and healthy way. I resigned myself to our way of life, and hoped that as he grew up, he would re-engage in our family on an emotionally healthy level.

When we went to our first parent teacher conference at the high school, prepared to hear complaints about his behavior, we were pleasantly surprised. "I love having Matthew in my class! He has such great insights in our discussions. He is thoughtful in helping others." Dave and I looked at each other and burst out laughing. "Really? You're talking about Matthew Gibbs, right?" Their experience with this young man bore little resemblance to ours, because Matthew could apparently manage his emotions at school but not at home. *Was it me he couldn't stand?* I tried to console myself by concluding that at least some of what I'd tried had worked.

The critical element of those stormy years was forgiveness. Sharp remarks across the table spoiled many otherwise enjoyable dinners between siblings. The simple question, "Have you practiced piano yet?", triggered hundreds of arguments or tearful meltdowns. Frustration over video games gone wrong erupted into unexpected outbursts that resonated through the entire house and could wake the dog from an afternoon nap. Conflict, anger, and unhappiness reigned in our house, while Dave, Anna, and I danced an intricate step to avoid an explo-

sion. We avoided sensitive topics. We tried not to question Matthew's statements. We didn't engage in debates over opinions, and we calmly deflected outbursts the best we could. We'd forgive, try to forget, then one of us would soon be caught in the crosshairs of Matthew's discontent again.

Matthew was living a daily existence of feeling inadequate within his family. Peers at school reminded him verbally and physically of his inadequacies. He received poor grades and other negative feedback about his inadequate academic and organizational skills. And he struggled to deal with internal questions that he knew would create conflict in the family, at school, and within our church and community. All of his feelings simmered inside him, creating a stew of misery that manifest itself in a scowling face, scrunched eyebrows, and surly responses.

My unhappy boy was becoming an unhappy man.

SECTION II: HER MOTHER

NEW PHASE OF LIFE

*M*atthew had his sights set on attending a private university that specializes in training designers, programmers, and graphic artists in the video game industry. Their program has high standards for acceptance and a notoriously rigorous academic curriculum.

Cautious optimism for Matthew's future filled Dave and I as we helped him move into an apartment near the university campus he'd be sharing with three other young men, also students. We hoped that learning academic fundamentals and the basic lessons of independent living, like managing a budget, cooking for himself, and time management might mean life would become a little easier for him as he pursued his dream.

Dave, Anna, and I settled into our nest as a reconfigured family unit. For the first time in her life, Anna was the only child at home. We no longer had to walk on eggshells to avert Matthew's ire. We could relax in our own home for the first time in many years.

Unfortunately, my health took a turn for the worse. My kidney was still working well. However, I had been

taking steroids and other antirejection drugs for over twenty-five years, which, over time, can damage bones and eyes, cause diabetes, and lower immunity. Doctors diagnosed me with several autoimmune diseases which were causing an inflammatory response, resulting in chronic pain in my muscles and joints. Pain became a constant and unwelcome companion, consuming most of my energy as I juggled the demands of work and motherhood. The progressive pain ultimately meant I could no longer safely negotiate the steep staircases in our home.

It was time for us to move once again. We downsized to a much smaller single-story house, two blocks down the street from the home in which we raised our children. Anna began her senior year of high school and was a busy girl involved in student government, symphonic band, pep band, elected president of the robotics team, the church youth group, raising money to travel to Poland for World Youth Day, dating, and hanging out with friends. She often seemed to be more of a drop-in guest than an actual resident. Our life was interesting, fun, and harmonious.

Another new phase of our life was on the horizon. Dave and I were on the brink of becoming empty nesters! Fully aware that many changes were coming my way, I anticipated the freedom and possibilities of what lay ahead. I looked forward to a few things I had been holding back on, such as time for myself to relax and rest and to care for my aching body. I loved the idea of a quiet household.

My enthusiasm waned as Anna's senior year progressed. Each event marked a *last* in her life and mine; the last first-day-of-school picture on the front porch; the last homecoming parade; the last robotics competition; and so on. I was aware of my impending loss early in the fall of that year as Anna agonized about which college she wanted to attend. She was torn between an instate school

and one that was three states away. She loved both schools but vacillated between her desire for the adventure of living somewhere far away, and her desire to be just a few hours away from the safety of home. She debated with herself for weeks, sharing her pros/cons list with us during every dinner we shared.

Mentally, I was rooting for the instate school because it was closer, but I also understood that this was her first adult decision and she needed to make it on her own. Eventually, Anna chose the instate school. Dave and I could enjoy our own newfound freedom. I could focus on my job without the daily pressures of being the mom. Quiet and peace would descend on our home. All of those dreams were about to come true, with the bonus that both kids lived close enough for us to gather frequently enough to remain involved in each other's lives.

It seemed I was going to have it all.

THE NEWS

*I*n the school where I taught, every teacher had a forty-five minute planning period that, when not consumed by a meeting, was time set aside to prepare material, grade papers, plan lessons, or sometimes just take a few deep breaths to regroup from the chaos that's already unleashed itself that day. On the first Wednesday of November, at the end of my planning period, I heard my phone buzz with notification of an incoming text. While I always ignored personal calls when children were in the room, this policy was more flexible during a planning period.

Matthew wants to come home on Sunday. He says he wants to talk to us about something.

I had several responses I wanted to send back to Dave.

What?

Why can't he just call us or tell us whatever it is on the phone?

What's going on?

Unfortunately, it was time for me to walk my class from the gym back to our classroom so our Scientist of the

Week could present her experiment for us. My questions would have to wait until I could release the little ones to their afternoon recess, when my time would be my own once again.

But Dave knew only what he had already written in his text. The shadow of mystery hung like an ominous sign over my thoughts as I tried to guess Matthew's news.

Recess ended, kids hung their coats on their hooks, chattering as they waited to get drinks from the fountain, and then settled into their preassigned late afternoon tasks. Some left the classroom to attend their small groups in other rooms. Those staying were to read or work on a daily math practice program using iPads. I listened to kids read. Or I looked like I was listening. I was sitting next to a child, my eyes were on the page, and if the child got stuck on a word, I would help them find a strategy to decode it.

My thoughts, however, were on Matthew. What could he need to tell us that requires scheduling an entire day to come see us? This was not normal. My mind was whirring.

Is he dropping out of school?

Oh, please Lord, please don't let him drop out of school. He has to finish school.

Please don't let him drop out of school.

This thought-storm was juxtaposed against the sound-track of seven-year-old voices reading Junie B. Jones and Flat Stanley.

Eventually, the last bus rolled out of the school's parking lot, and, uncharacteristically, I left for home right away. I would tidy the room and sort and grade papers in the morning. I pulled into our driveway, meeting Anna, who had also just arrived. She was bent over pulling her backpack out of her car as I blurted, "What's going on with Matthew?"

She straightened up, looking at me as if I had lost my mind. "Huh?" Anna said, having no context in which to

understand my question. My voice rose and my speech sped up, explaining to Anna about Matthew's text to Dad, what my worries were, and my sense of an impending crisis. If she knew anything, she needed to tell me.

Now.

Anna knew nothing. But she intended to find out what Matthew was doing, or had done, to send me into a tailspin. Which meant, by extension, her life would soon spin too. She marched straight to her room, closed the door, and texted her brother. He swore her to secrecy. He told her the secret he'd kept for years . . . the secret he wanted to tell us in person over the weekend. They both agreed it was his news to tell.

The afternoon slipped away from us, and even though I'd arrived home an hour earlier than usual, it was early evening by the time I realized we still needed to go to the bank and Anna needed to buy materials for an English project. Dave, Anna, and I ran the errands together and then went out for Mexican food afterwards. I used my well-worn interrogation techniques, taking advantage of Anna's entrapment in the moving car as we traveled to the shopping center.

"What did Matthew say when you talked to him?"

"It isn't my news to tell, Mom."

"Is he okay?" I used my most conspiratorial voice.

"It isn't my news to tell."

What? Anna has always been more than happy to be my spy and informant! And she chooses now to be her brother's ally?

"Is he dropping out of school?"

"Mom!"

Anna is a smart girl. She caught on fast and wouldn't play. I gave up. I didn't know what Matthew wanted to tell us, but somehow I knew our lives were about to change.

Significantly.

The next day, I was in a state of limbo, a state of waiting, of worry. Anna was at a meeting for the robotics club that evening, so Dave and I ate dinner together, just the two of us.

"I met with Matthew earlier today."

I put down my fork and waited for Dave to continue.

"He wants to become a woman. He says he's transgender."

The floor seemed to shift on its axis. The air left my lungs, and I squeezed my eyes shut against the world and my hands around the edges of the table. I had no idea how much time had passed. Maybe minutes. Maybe only seconds. When I could breathe again, I finally opened my eyes. Suddenly what had seemed so outrageous and upsetting yesterday was what I wished for now, that Matthew was simply dropping out of school.

Dave reached his hand across the table to connect with mine. We finished eating in silence. I excused myself, crawled under the covers of our bed, and cried. Grief washed over me in waves, knowing that this evening and this brief time, Dave and I home alone fresh with the news, might be the last time I could freely allow myself to *feel*. And feel I most certainly did.

I defined that moment as the marker of the *before* and *after* in my life. When everything I knew, or thought I knew, and everything I believed to be true about myself, my children, my family, and our family's history was a lie.

Soon, Dave came to check on me. I sat up in bed, wiping my red and swollen eyes. I sniffled. "How did you get Matthew to tell you this?"

"I texted him this morning and offered to pay for the switch to snow tires on his car if he could meet me at the tire store at lunchtime." Matthew's apartment was a few blocks from Dave's office, so while this was a generous offer from Dave, it was also a reasonable arrangement for

both of them. "As we were waiting for the tire change, I told him that his cryptic message about having news but asking us to wait until Sunday to hear it, was causing us a lot of worry. That's when he blurted it out."

Dave said he heard fear in Matthew's voice. Suspecting that Matthew worried we'd reject him, Dave held Matthew tight and whispered, "I love you." Dave suggested I do the same and let Matthew know I wouldn't abandon him either. I knew it was sound advice, so I got up long enough to send Matthew a text.

I love you, no matter what.

Friday mornings usually began with a comforting routine I shared with Debbie, a fellow teacher and friend. She would stop at a coffee stand to buy designer coffees for each of us and we would pass the early morning hours before the school woke and share stories about our week. Debbie already knew I'd been waiting for Matthew's mysterious bombshell to reveal itself, and as we sipped our mochas in her chilly room, I told her the news.

She set her cup down, came over to me, and gave me a long hug. Debbie has had her share of struggles, imbuing her with a keen sense of empathy for the helplessness that can accompany some of the more tough situations adult children can raise. We talked about my worry for Matthew and the confusion I felt about this momentous news. Time ran out on our conversation while there was more to say. But the school day was dawning. My red eyes needed time to clear, and my face needed a smile. I would do my best to keep my family and all of its questions, worries, and fears in a box with a tightly fitted lid tucked away deep inside my mind until the day was over.

That afternoon, once I settled in at home, I saw that Matthew had emailed links to articles about gender dysphoria, transgender people coming out to their families, and the potential relationship between autism and

gender dysphoria. He had gone to so much effort, done his research, and was presenting his case. It lent gravitas to his message.

I, however, couldn't make myself read what he sent. Emotional turmoil consumed me. I retired to bed early again, unwilling or unable to talk with Dave or Anna about any of it. I needed time to process my feelings before I could form words to express them. I awoke long before dawn on Saturday morning, a tide of pain coursing through me. I picked up a stray notebook from my home office and let my thoughts, raw and jumbled, litter the paper.

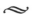

This is the 3rd morning since Matthew texted
Dave saying he wanted to come home to talk to
us. It's the morning after another night of crying.
Another morning lying in bed, not wanting to get
up ever again.

M-A-T-T-H-E-W, that's you! This was a chant I
made up that used to make him laugh when he
was a baby. He was my baby boy. I brought a baby
boy into the world. I brought a baby boy to
church for baptism. It was my little boy who spent
entire afternoons getting in and out of his play car,
filling it up with pretend gas, and then going back
for another ride around the carport. It was my
little boy who would play endlessly with the icy
water coming out the downspout on rainy days
until we had to change his clothes. It was my little
boy who would climb into the barber chair and
say, "A number two all over," cracking everybody
up. It was my boy who worried that he'd be short

forever. It was my boy who loved his dogs—a little too much for the dogs perhaps, but he loved them all the same. My boy who fought with me, blamed me, and gradually turned angry and sullen.

∼

Matthew was my *boy*.

TACO SOUP

*S*unday finally arrived, and, as I had done Saturday, I woke and quietly left the bedroom so as not to wake Dave, and I tiptoed down the hall past Anna's closed door. I sat in the living room, sipping hot coffee from my favorite mug, focused on the row of scrapbooks neatly lined on the bookshelf across the room. *How much of my life . . . of Matthew's life . . . was captured within the pages of those books? What does Matthew remember? What does he think and feel when he sees these pictures?* I didn't know. Apparently, I didn't know who he was. Who he is. Who she is. I brushed at a tickle on my cheek and my hand came away wet.

That afternoon I assembled a big pot of taco soup, one of Matthew's favorite meals, and set it on the stove to simmer. When Matthew arrived, Mila barked and ran crazed puppy circles around him as he walked through the front door, oblivious to the tectonic shifts in our world. Once Mila wound down, Dave and I approached Matthew in the entryway. Our son stood at the threshold of our home, looked me in the eye and said, "I want to become a woman."

Hearing those words out loud, direct from my son, sucked the air out of me once again. My mind was whirling, my heart was breaking, and I really didn't understand. I didn't understand what he was going through, why he wanted to change his gender, and I didn't even understand my response. But I didn't say any of those things. I reached out and hugged him. "I love you. I love you no matter what. I can't think of anything that you could do that would ever make me stop loving you."

Matthew and I pulled apart, tears in our eyes, and I turned to see tears in Dave's eyes too. He also hugged Matthew and reaffirmed his love. Anna stayed in her room until dinner to allow us time to talk.

Dave sat down in his recliner and Matthew and I perched across from him on the couch. The conversation that unfolded felt more open, honest, and candid than any we'd had before. Dave and I asked questions that were personal and direct, and that also revealed our ignorance on the subject of gender dysphoria. Matthew answered us honestly, but also gently. He treated our feelings with care, in what I realized partway through the discussion was a remarkable change. How he handled himself and us that late Sunday afternoon showed that he cared deeply about keeping our relationship intact.

"How long have you known?" I asked. Tearfully, Matthew explained that he had felt like he was really a woman for a long time. Since the onset of puberty, he knew he was different from other boys, but he didn't have a name for what was different until high school when he read an article about gender dysphoria. It immediately made sense to him, and he finally had a name for his experience. He told us about the sense of relief that washed over him as he read stories written by other people who, like him, felt out of place in their own bodies and desired,

more than anything, to inhabit the body of the opposite gender.

"How have you kept this to yourself all this time?" I wanted to know.

"I just did," Matthew told us patiently. "You didn't want to hear it. Any time I tried to tell you and Dad, you guys would shut me down." Dave and I glanced at each other, clueless about when Matthew had ever broached this subject. "When I was a senior, and then when I lived here the year after high school, I would lock my bedroom door while I wore girl clothes. It helped me release the tension."

It stunned me. My son had been dressing in girl clothes while locked in his room, and we had *no clue*.

A memory stirred in the back of my mind. One morning, two years ago, Anna couldn't find her favorite bra. She searched for it in every likely place, and I helped her look in every *unlikely* place. We finally surrendered, wondering if the friend who spent the night the previous weekend had accidentally packed it in her bag.

"Is that where Anna's bra went?" I asked.

He lowered his eyes and with a half smile said, "Yeah."

We all burst out laughing, a much-needed tension reliever after all the angst. "You heard us searching for that bra and you let us keep looking?"

"Well," Matthew's voice more animated now, "I sure wasn't going to tell you I had it hidden in my closet and that I liked to wear it, was I?" Then he graced us with his beautiful full grin. It turned out that Matthew had also sneaked out a pair of her jeans and a shirt. I paused to think, as an image formed in my head. Anna is about six inches shorter than Matthew and at least sixty pounds lighter. I tried, unsuccessfully, to envision how the clothes could even fit on his frame. "How did you get them on? Weren't they a little small?"

"Yeah, I didn't say it was pretty. I made it work." I just laughed and hugged him again.

Matthew told us he had stopped wearing girls' clothes when he moved into the apartment with the guys from school last year. There wasn't enough privacy, and he wanted to fit in. His plan had been to continue living as a male until he finished college and then transition.

"What made you come out now?"

"I hate my male body so much," Matthew confided. "I can't stand to live like this anymore."

Dave got up and brought us a box of tissues because the tears were flowing rivers now.

I knew Matthew was depressed. I was concerned that changing gender would solve his depression the same way a Band-Aid is a solution for a gushing wound. Would he just go from being *depressed Matthew* to *depressed new-name*? And would he discover that his problems would still be there only to find he'd made an irreversible mistake?

Matthew was relieved that we had not shunned him, as he had heard so many other transgender friends and acquaintances recount rejection from their families when they came out. But he didn't know how the rest of the family and our friends would react.

"Please don't tell the rest of the family. I want to have one more Thanksgiving and Christmas and I don't know if everybody will accept me once they know."

I wasn't sure I could keep this to myself for six weeks. I tend to share big news with the people I love. My world had shifted in ways that I couldn't even identify yet, and I would need support. But Matthew's request was fair. It was his story, and he had the right to control its release.

The soup steamed up the windows as our stomachs grumbled. We called Anna to come and join us as we set out bowls of cheese, sour cream, chips, and our large serving bowl filled with thick soup packing a southwestern

kick. My heart filled with joy to be sitting together as a family once again, saying grace over our meal.

Dipping chips into her soup, Anna had a question too. "What is your new name going to be?"

"I've decided it's Tamara, pronounced like ta-maw-rah."

There we were. The Gibbs family: Dave, Anna, Tamara, and me.

Matthew was gone.

ABC LGBTQ

I knew so little about what it really means to be transgender. The first time I encountered the term *gender dysphoria* was when skimming one article Matthew had sent to me on Friday. I was vaguely aware of the term LGBTQ, really an acronym, but I had never known, or taken an interest in, what the T or the Q represented. Lesbian, gay, bisexual, transgender and queer. As far as I knew, I had never met a transgender person. I was full of questions.

If Matthew was transgender, wouldn't he have shown cross-gender play or dress tendencies as a child?

Weren't transgender people the girls who are super tomboys or the boys who play dress up or play with dolls?

It was another Saturday morning, and I was once again flipping through page after page of our scrapbooks, looking for signs like these from the boy in the pictures. I saw nothing. He didn't play dress up. He didn't play with dolls.

I had several other preconceived ideas about transgenderism. I understood the notion that some people are born into the wrong gender and may need to change in order to

align their true identity with their physical appearance, but it made little sense to me. Sexuality and their changing bodies has always been a source of conflict for teens. Couldn't this be a fad, with more teenagers identifying as transgender than ever before? Was it more than a fashion trend? Aren't they seeking attention? Are teenagers mature enough to make such a grave decision as becoming transgender, physically changing their birth sex? It's such a permanent solution for something that could be temporary teenage angst.

Anna lumbered into the living room, bundled in her fuzzy bathrobe and still half asleep, carrying a cup of coffee back to her bedroom.

Forgetting to say good morning, I asked her, "Did you ever feel you had a sister living in the room next to you?"

"No, but I never felt like I had a brother either," she answered.

Her answer stopped me cold. Matthew may not have been dressing up as a princess, but neither was he turning every stick into a sword or light saber. He didn't play house or family with dolls, but neither had he displayed any interest in digging ditches with play tractors. He had never gravitated one way or the other to gender based play preferences.

I was beginning to understand that being transgender was about more than a physical sex change. It was memory, identity, and relationships. Into my jumbled mind popped a thought that shocked me. *Matthew is dying, ceasing to exist.* I was confused, and afraid to say anything about this to Dave. We had raised a child we've always known as Matthew. Matthew had a certain set of characteristics we understood. We thought we knew our son well. Now, it was apparent that the Matthew we *knew* was playing a role for the benefit of other people, including us, and that our child's real self is someone else

entirely. Matthew was not just leaving, but it was possible that he hadn't existed for a very long time.

Eventually, Dave wandered into the room and sat next to me, sipping his coffee. He looked at the open scrapbooks spread before me. He let out a heavy sigh. "It feels like Matthew has died."

I set my coffee cup down on the table, hard. So hard that a little slopped over the rim, making a puddle I would normally have leapt up to clean. I just stared at the liquid mess. Without raising my eyes, I said, "I was just thinking the same thing."

It was a relief to get that in the open. I had felt so ashamed of myself for thinking that way. No one died, and it didn't seem fair to compare our loss to the loss experienced by parents who have lost their child to death. Rational thought told me I would be blessed with a new daughter who would fill the void left by Matthew.

However, Dave and I loved Matthew, and we just weren't ready to see him fade.

MODUS OPERANDI

*M*y usual modus operandi when navigating a crisis is to take control of the chaos. The first step is to research and learn as much about the issue as possible. The second step is to identify what needs I will probably have because of this crisis or issue. Finally, I build a support system to help me fill the needs, overcome obstacles, and solve problems. Even after passing a day or two at my pity party, I always come back to reality, ready to dig deep into my energy reserves and use these strategies to work my way through tough times. I am a fighter. I am a survivor. I know how to overcome. I'd had practice.

This time, things were different. It knocked me flat. I felt sad, alone, and apathetic about helping myself. I didn't care if I did any research. I didn't feel like reaching out to support groups. I didn't want to dig deep in my soul and maneuver through this. I just kept crying.

Dave was getting worried: this wasn't how his wife, the mother of his children, does tough times. If I wasn't going to do the research myself, he nudged me along by sending me links to articles. They sat in my inbox, unopened. He broached subjects covered in the articles, but the conversa-

tions fell flat. I could not summon the energy to take control of my own emotions. I was scaring myself. *What if this really was the final crisis that marked my tipping point? What if I stopped being the strong, resilient person I have always been and am now broken?*

Through the next few weeks, I passed each day in a hazy fog. I taught on autopilot, returned home, cried for a while, graded papers or wrote lesson plans in the evenings, went to bed early, cried myself to sleep, woke up every night around two o'clock, cried for another hour, and then woke in the morning to do it all again. I forgot to defrost meat for dinners (we ate a lot of eggs and toast). I didn't bother with housekeeping, and laundry piled up. Coworkers noticed I was inexplicably distant, disconnected, and unusually disinclined to disclose an explanation. Questions, despair, loss, grief, and attempts to come to grips with Matthew's gender change occupied my thoughts. While executing routine tasks, my internal machinations consumed so much mental energy that my thoughts seemed to take on a life of their own. Matthew's request that I not share the news removed from me a key pillar in my usual coping strategy. I lived inside my head, isolating myself from the outside world.

One day, my lesson plan was to facilitate a lab experiment on wind erosion for each of our second-grade classes, repeating the same lesson four times through the day, rotating groups through my room. This fun and exciting lesson is most successful when I am on what I call my A game. It requires a lot of organization and preparation, and strong behavioral management skills on my part. Students built model hills made of wet sand (think of a sandcastle, but without the architectural embellishments), then mimic the wind's role in erosion by blowing through a straw.

As a teacher, the trickiest elements of these types of

lessons are time management (derailments from the plan potentially result in not achieving the learning objective), managing cleanup and preparation for the next group, and then recording and analyzing their scientific results (because scientists record their data and draw conclusions). If I didn't use my practiced teaching skills today and keep my attention focused on everything going on around me, chaos would reign. Not only did I need to be physically present, I needed to be there emotionally and mentally. What I wanted was to be alone, in my bed, buried under the covers, hiding from the world.

Fortunately, the lessons proceeded fairly well with only a few spills and excessive windy conditions. The kids learned what they needed to learn about erosion, but sadly, I was not truly engaged with the lesson or the kids.

I knew I had to pull myself out of this abyss. Were my reactions and emotions normal? Did other parents also experience this paralyzing fear, worry, anxiety, and grief for their child? I had no frame of reference for what was happening, so I forced myself to read the articles Tamara and Dave had passed on to me. I searched for books written by parents who had navigated the world of having an adult transgender offspring.

Finally, I was engaging in my life. Despite my sadness, or perhaps because of it, the time had come to dig deep, find my inner strength, and control the chaos in my mind so I could move our family forward. I devoured information from these books and articles, searching for clues on how to navigate this new world order.

Matthew was no longer a teenager, but his social and emotional development had always been delayed by two to three years. At twenty years old, I could confidently pinpoint his socio-emotional development to be approximately that of a seventeen or eighteen-year-old. Matthew seemed mature enough to have passed the confusion and

questioning phase of his sexuality. Matthew told us that the confusion and pain over being different when he was younger were not the product of teen angst, but the cause of it.

Matthew was asking me to prove my unconditional love by letting him go and embracing the emerging Tamara. How could I let him go? Hadn't I invested twenty years helping Matthew grow into an amazing and wonderful adult? And now . . . I should just say goodbye? I didn't think I could do that. At least, not before I understood who, exactly, Tamara was going to be. I needed to understand what it would mean for Matthew and for us, his family, to transition into becoming her. At that moment, I couldn't see how to get there from where I was.

It was late on a Wednesday evening when I closed the last book on my reading list. Dave was asleep, the house was quiet, and the last embers were burning out in the fireplace. I needed to go to bed myself so I could be ready to work the following day, but I stayed on the couch to savor the peace of that moment. I mulled over the implications of what I had just read.

THANKSGIVING

Tamara arrived at our house early on Thanksgiving afternoon, ready to join us for the final three-mile drive to my brother's house for dinner. Tamara played the role of Matthew that evening, having asked us to keep her news from the rest of the family until Christmas passed. Watching the performance was agony for me. She played her part well., she was well-rehearsed.

"Let's get a picture of all the grandkids together!" (*But she hates how she looks right now . . .*)

"Wow, your hair's getting so long. It looks like a girl's. Soon it'll be as long as Anna's." (*That's what she wants. She wants you to tell her it's pretty, not strange.*)

"Hey, Matthew and Ryan, you boys need to come eat some of these leftovers! You're growing boys, it's good for you!" (*Do we have to make a big deal out of being male here and now?*)

Driving home that night, I replayed the day in my head, analyzing scenes that triggered an emotional response, both for me and, I was certain, for Tamara. I had a new appreciation for her acting skill, playing the part of Matthew and keeping Tamara hidden away, even if only

for a few hours. *How long had Tamara been playing the part of Matthew? How many times had I been a part of the unknowing audience, complicit in perpetuating her pain? What has this been like for her and for how many years?*

I found it nearly impossible to imagine a repeat of the Thanksgiving performance at Christmas. I thought it was time for Tamara to let Matthew retire.

"Mom, no. I have no idea how they'll react, and I'd like to have one last happy holiday memory." Tamara made a fair point. I had no idea how the rest of the family would react either. I sensed it would be okay, but I didn't know for sure. Still, she compromised and agreed that we could tell the family, but without her being present, and after she had left for home.

Dave and I rolled out of bed the next morning, dreading the day ahead. The sky was clear. The sun was shining, and the crisp air pushed our dark moods aside as we waved goodbye to Tamara, hugging our steaming coffee cups close as a talisman that might ward off the chill of the hard work ahead. We walked back into the house and tackled the upcoming day with humor.

"What does one wear to tell one's parents that their grandson is really a granddaughter?"

"Is there some food we should bring as an offering?"

It felt good to smile. In a blink, we had driven the ten minutes to my parents' home. My dad started small talk until I summoned the courage to speak. "We're actually here because we have news."

My mother's face drained of color. I blurted, "Matthew is transgender." Neither of my parents did or said anything for what seemed like a long time but was only seconds. Soon we were in a lively conversation that reflected the kindness, love, and acceptance that has always defined my relationship with my parents.

"What happened that made Matthew do this?"

"Is it possible it's a phase?"

"Does he have to go through counseling before making any physical changes?"

They didn't profess to understand why Matthew would want or need to change gender, but they clarified that they would accept Matthew no matter what.

"What name should we put on her Christmas gifts?" Like ours, their love was unconditional.

Then I called my sister-in-law, Megan, to see if they were home and had time for us to drop in. My request confused her. We had just spent the day at their house yesterday, and now we wanted to visit again.

We sat down at their kitchen table and immediately shared the news.

My brother Jim, who had been Matthew's high school counselor as well as his uncle, was familiar with our son's black moods. He lit up with a smile. "Good for him!" My mouth dropped open, and this time they were tears of gratitude that spilled down my cheeks. "It's been obvious that Matthew has been in pain for a long time—at least for his teenage years, and even a few years before that. If Matthew has finally figured out what was causing all of that pain, then good for him. Or good for her. I hope she can be happy."

These were the words I needed to hear. I suddenly saw a way to understand, accept, and embrace the changes happening to Matthew and our family. Jim's reaction helped me see there was a future where it was possible Matthew could find joy in life—as Tamara—in ways he/she never could before. This was my first step in accepting that my son really could become my daughter, and it would be more than okay.

It might even be a good thing.

KEITH THE COUNSELOR

*M*atthew/Tamara called to tell me she had made a series of weekly appointments with a counselor. "Could you both be there for one of them?" she asked. I pulled the phone away from my ear and stared at it.

Who are you? And what have you done with my child?

Matthew had been a habitual procrastinator who also avoided communicating with people over the telephone as much as he could. The fact of him taking immediate initiative to research counselors and book appointments was testimony to his commitment. He would do whatever it took to change gender.

On the appointed afternoon, I left my class in the capable hands of a substitute teacher and picked up Dave, who was working from home. We headed for more unknown territory, driving for an hour in silence, each of us occupied by the narratives in our minds. We arrived early at the counselor's office and sat in the cool, empty hallway that echoed every word we spoke. When Tamara turned the corner on the staircase a few minutes later, we greeted her with hushed whispers and scooted on the

bench to make room for her to sit. Dave cracked jokes, Tamara cracked her knuckles, and I bounced my knees up and down. Finally, the door opened and Keith, the counselor, ushered us into his den. I wasn't sure what to expect.

It was only later that I began referring to him as Keith the Counselor. Over many crises and many months, I witnessed the incredible support and guidance he provided to my child, making things infinitely more manageable. Keith the Counselor was a superhero. But during this first meeting, I wasn't at all sure.

The size of his large office surprised me. Dave and I sat together on a comfortable couch while Tamara sat in a matching chair at a right angle to the couch, turned towards us. Keith placed himself far outside of our cocoon. We sat in uncomfortable silence, Keith waiting for one of us to start the conversation. I broke the ice and got us started.

"We're here because we're hoping you can help us understand Tamara's plans to switch gender, and maybe explain how we can help her," I said. I added that we just needed a professional's perspective.

"Learning how to support Tamara is a positive goal," Keith told us. "As parents, I'm sure you are experiencing your own kind of pain because your hopes and dreams for your child's future are changing."

Changing? I wanted to scream. That only scratched the surface of all the feelings we were processing.

I wanted to tell him this was about much more than disappointment over not having grandchildren from ~~Matthew~~ Tamara. But I calmed myself down, focused on why we were there, and kept quiet. We were there to hear about how we could help Tamara, not to counsel me and Dave through our grief and loss.

Keith continued to tell us how much he appreciated Tamara, all that she has overcome, and how much

resilience he sees in her. Keith showed that he had already built a strong relationship with my child and seemed to have her best interests at heart, redeeming himself in my eyes after his earlier misinterpretation of our experience.

Our discussion moved on to territory I'd only become aware of in my recent reading of the articles Tamara and Dave had shared with me. Nearly every article, book, or blog post I read seemed to cite astronomical statistics about the connection between rejection by the family and subsequent suicide rates in the transgender population. My Matthew had been in distress, but surely not in despair. We hadn't rejected him, but the news still shocked us. I was certain we were not at risk of becoming a similar statistic. Still, it seemed the safest place to ask the question.

"If we hadn't responded to your news the way we did, if we had been less accepting of your decision, were you prepared to harm yourself?" I could hear Keith's clock ticking away the seconds as I waited for her response. Tamara lowered her eyes.

"Yes," she said, almost whispering, "I was prepared to end it."

CRAA-A-A-ACKKK.

Another belief shattered. Accepting our child's gender change was hard, but it was nothing compared to how hard it would be to lose ~~Matthew~~ Tamara altogether. *Oh, thank you Lord for giving us the wisdom and the heart to say the right words when we needed them.*

In the very next breath, Tamara continued. "I still hate everything about myself. I hate everything about my life."

I asked what, exactly, was causing her unhappiness. But she couldn't be more specific than, "I just feel like everything would be easier if it was all over."

Bile rose in my throat. I looked from Tamara to Dave to Keith and back to Dave, trying to find an anchor in this

storm. Keith the Counselor didn't seem surprised. Or concerned. Dave's face had gone blank. After thirty years together, I know what that means. He was on overload and couldn't process what was happening fast enough to keep up with the expectation of taking action, even if the only action required was to talk. He was frozen.

And I had an epiphany. *Matthew had not come to us to ask for permission to change gender, but for our blessing.* It was a subtle shift, significant only in my head, but in that moment I understood. My heart raced and a lump grew in my throat, suddenly comprehending the gravity of ~~Matthew~~ Tamara's emotional state.

I had reached the end of my ability to ask Tamara about her self-hatred, and how she would deal with her suicidal thoughts during the time she was transitioning genders. I stared Keith down, willing him to say something, do something, be the authority in the room.

Finally, Keith took over and guided Tamara through strategies she could employ when self-destructive thoughts consumed her, like identifying who she should call or distracting herself by doing something else.

"What if you took a drive?" Keith suggested.

"I tried that last night and I realized I was in a method," Tamara said. "I scared myself and went home." Silence draped the room as the three of us puzzled out what Tamara had just said. *A method?* One by one, each of us got it: Tamara could use the car as a tool for suicide.

I wanted to go to the place where Dave was. Frozen. I was on overload too. From a child who was changing gender, to hating her life, to contemplating suicide . . . I wanted off this ride. After a few more thwarted suggestions, Keith finally delivered one that pulled Dave out from his shell-shocked state. Together they convinced Tamara that it was okay for her to call Dave any time, day

or night, if she needed to talk, and it would not upset Dave.

Our hour was up. I heard Keith saying, "It was nice to meet you . . ." and, "Tamara, we have an appointment next week on . . ."

What?

We can't leave now!

Didn't you hear that my baby was just talking about killing herself?

Do something!

How can you send us off like this?

I said all of this telepathically, of course, but Keith either wasn't listening, or he was very good at his job and knew that Tamara was closer to healing than self-harming. Or maybe mind-reading wasn't one of his superpowers.

Regardless, we walked outside into the darkening sky of the late November afternoon and offered to take Tamara out for dinner. We agreed on a funky pizza restaurant that Dave and Tamara recommended, and then Tamara took off in her car. Dave and I stood by our car with a chilly wind whipping under our coats.

"Did that really happen? Did we just spend the last hour listening to our son talk about how she wants to kill herself?" I was too distraught to find humor in my accidental mixing of the gender pronouns. Dave wrapped his arms around me, and I buried my head in his chest. In the saddest voice I've ever heard, Dave said, "Yes, that was exactly what happened."

The restaurant was filling with people going about the ordinary ritual of ordering their food, choosing tables, and engaging in normal conversation. We'd just experienced another seismic shift as a family, and we were still stiff and awkward together after the revelations of our counseling session. We shuffled to a corner of the restaurant, as far

away from other people as we could. Dave and Tamara sat down, their shoulders sagging.

At that moment, I decided. It was time to move on. Matthew, our son, would become Tamara, our daughter, no matter how many fears I had about it, how many questions I still had, and no matter how much grief I still needed to process. In our family, we often encouraged each other with the adage, "It is what it is." This was the way it was now. This moment seemed like the right time to engage in this laissez-faire attitude.

Within ten seconds, I progressed from deciding to making a declaration. I slammed my purse on the table.

"Okay, enough with all the sad talk. Tell me something that you are looking forward to," and I sat down opposite Dave and Tamara.

Tamara mumbled something about *not being trapped*, and I interrupted her.

"No, I mean specifically. What is one thing you are looking forward to about being a woman? Hair? Clothes? Makeup? Some parts of being a woman are fun. What part do you really want?"

She smiled and answered without hesitation.

"Clothes."

ANGRY WITH GOD

I have a powerful faith in God's faithfulness to all of us. Good times inspire prayers of gratitude, and during trying times I turn to Him for support.

After Matthew's coming out, I was, for a time, unable to be thankful or to lean into God's grace. At first, my prayers were of self-pity. *I can't do this. This is too hard.*

Soon, I discovered I was actually angry. I was furious with God for putting Matthew in this situation of pain. *Wasn't life already hard enough for him? How could he have lived through so many years feeling that life was so devoid of meaning that he wanted to end it all? Where was God in all of that? Why couldn't He make Himself known to Matthew when Matthew needed comfort the most?*

Where was God when Dave and I were mourning the loss of our son? I was livid that God seemed so absent in all of this.

One Saturday afternoon, I stopped by the empty church, sat alone and tried to pray. I couldn't concentrate and my mind wandered into memories of happier times. Our family had celebrated so many milestones here—baptisms, first communions, and confirmations. This had

been my happy place for years, and now it seemed like a sham. Everything I had to say reflected my sense of betrayal.

Really, God?

Haven't we been through enough?

Why does everything have to be so hard?

I sat there for nearly an hour, waiting for the familiar feeling of comfort to wash over me. I felt nothing. I was empty. I didn't lose my belief in God's existence, but I doubted his faithfulness to me.

I thought about what church must have meant to Matthew when coming here as a teenager. The volunteer who ran the youth group at our church, the group Matthew had been a part of, was vocal about her personal, often extreme, antigay sentiments. "Doesn't God love everyone?" I imagined Matthew wondering, "If God only loves heterosexuals, how could He possibly love me? Maybe I'm not worthy of His love."

Suspicious that this sentiment was more widely shared by others in the congregation, I stopped going to church altogether. I was afraid their opinions would overwhelm me with sadness and anger. Instead, I woke up on Sundays and sat in my pajamas, drinking bottomless cups of coffee with the newspaper spread out before me. I may have looked like I was at peace, reading the weekly news, but the words blurred while endless thoughts about my absence from the church community took center stage in my head.

The church and bible both say plenty about sex, sexuality, and sin. Sexuality, gender identification, and reproductive matters have taken on moral implications. Exclusion from the community is the consequence for violating the standards of church doctrine. My child was no longer welcome here. Questions arose within me like the bubbles that rise in a pot of boiling water.

If the Church, as an institution, proclaims that LGBTQ people aren't welcome, how do I justify continuing to participate as a member?

How can I be a part of an institution that rejects my child in the name of God's teaching?

How does the Church's response reflect what I understand Jesus stood for as an advocate for marginalized people and love for all?

Will my friends from church stand by me?

Will they accept Tamara? What if they don't?

What precisely does that mean in terms of what was real in the relationships that have been important to me?

If I was ever going to make peace with God and continue to take part in our church community, I had to answer these questions. It felt hypocritical to go to church on Sunday when I so strongly disagreed with teachings telling us we should abandon those who need us the most.

One sunny afternoon, alone in my empty classroom after the kids had gone home, I was preparing materials for the following day's lessons and slipped into a daydream. When I was in the fourth grade, everyone in the class received our own New Testament Bibles. I was so excited to have my own copy, and the translation used clear language accessible to my ten-year-old reading level while staying true to the context. I'll always remember the brand-new book smell of that bible and the accompanying feelings of hope and joy.

Mrs. Brown, my teacher, put those bibles to good use that year. We learned how to cite passages and find references using book, chapter, and verse. We re-enacted parables, and we learned what the words and actions of Jesus meant to those around him—and still mean to us today. My daydream took me to the time Mrs. Brown walked us into the church, gathered us around the altar, and read aloud passages from scripture describing the time Jesus

spent with prostitutes and tax collectors, his love for everyone and his call for us to love one another. These stories made me feel warm and safe, like a blanket wrapped around me to ward off the cold.

A shiver of insight went down my spine, startling me out of my reverie. I had, quite literally, learned about unconditional love *in this church*! If the bible taught that lesson, through our church, then it makes made sense to extrapolate that God's unconditional love extends to transgender people too. Even though I couldn't reconcile myself to the church's exclusion of certain people from the community, I knew that, biblically speaking, *I* was called to love all of God's people, especially my transgender daughter. If Jesus could dine with the outcasts of his time, then *I* could comfortably participate in church life, knowing love and inclusion formed the basis of our core beliefs and teachings. And, perhaps I saw that I could forgive those members of our church community unable to feel as welcoming to my transgender daughter as I was. They didn't know any better, and I chose not to let them interfere with my religious convictions and participation.

I resumed my practice of attending mass on Sundays, and it was comforting to be with our church friends once again. Fear of judgement and rejection still kept me from sharing what was happening in our family, although I hoped and prayed that in time they would continue to accept us with love.

Including Tamara.

NIGHTMARE

*E*arly one morning, I woke drenched in sweat. I'd dreamt I walked into Matthew's apartment to find him hanging from the end of a rope. Tamara's disclosure about suicidal thoughts had filled me with paralyzing fear. About a week after the appointment with Keith the Counselor, the phone rang at one o'clock in the morning, causing Dave and I to jump from the bed in a state of panic before Dave could think clearly enough to answer his phone. It was Matthew. His car had died while in the all-night drive-thru at Taco Bell. And Taco Bell wanted him to get his car moved. Seriously? At least it was just the car that died. (We enrolled the whole family in an auto club the next day.)

At school, staff generally kept cell phones off during class time. Concerned about Tamara's safety, I rebelled by keeping my phone in my pocket and turned on. I worried I'd receive a call at any moment from the police or hospital.

My performance at work was suffering. The changes in my behavior confused and frustrated my coworkers. It was time to offer my boss, the principal, an explanation. I

asked her to meet in my classroom during planning time, instead of her office with its many interruptions. This would be a tough conversation, and I craved privacy and her full attention.

"I'm not sure if you've noticed, but for the last few weeks I've been somewhat detached from things around here." Karen's face gave nothing away. "I've been dealing with a big crisis in my family." Karen raised her eyebrows, but she remained quiet as I paused before confessing the truth.

"Matthew is suicidal." The dam broke, and I was gushing tears once again. I was getting a little tired of having red puffy eyes.

Karen's face melted into an expression of empathy and concern as she reached out for my hands. "Oh, my goodness," she whispered.

I plowed forward and told her that Matthew had recently come out as transgender. I asked for her grace and understanding in that I might push boundaries on things that might be uncharacteristic for me, like having my phone on during school hours, leaving campus right after the dismissal bell, or perhaps being a little distracted during meetings or while teaching. She asked how Dave and Anna were doing and said she would do what she could to support me during this difficult time. Right then, I thought she was the best boss in the world.

By the middle of December, I had told my family, my boss, my immediate coworkers (the other second grade teachers), and a few local friends. Dave and I agreed that it was time to reach out to other people who needed to know—family and friends who live beyond the borders of our town. Dave emailed his six brothers and sisters, unsure of what to expect back from them. Lisa and Oliver, the sister- and brother-in-law that we see most often, and with whom Matthew has had the closest relationship, sent a

reply message that was truly touching. Living in the heart of a conservative area of the country, Ollie told us that Tamara would always have a place to stay in their home if she is passing through their neck of the woods. None of Dave's other siblings replied.

I reached out to my dearest friend, Anne, who was my roommate the year I met Dave, and now lives in an adjoining state. We'd been close friends with Anne and her husband Carl since college, spending weekends and vacations, with and without our children, several times every year. I wanted to get the words just right and wrote a letter which I sent over email. While she has always been a loving and accepting friend to me and our entire family, I still felt anxious about dropping this bombshell.

She called me the following day. I sprawled across my bed with the speaker phone resting on a pillow, pouring out my heart for over an hour. I told her things I had filtered out of conversations with other people, when I didn't want to over share or become a burden. I described the vivid dreams about finding Matthew dead. I admitted to long, sleepless hours spent crying in the darkest hours of the night. I shared my worry about whether Matthew was making a mistake. Anne asked how this could be possible when Matthew never cross-dressed or even engaged in cross-play as a child. She wondered aloud if this might be a phase. She asked if he was planning to have the surgery. Anne asked the same questions I had asked, the same questions my family had asked, the same questions my other friends had asked, and the same questions that my coworkers had asked.

One Sunday, I saw Anna's godmother. Diane is caring and compassionate to everyone she meets, and I knew that she would be a safe choice to be the first person in the church community for me to share about Tamara's new life. I was confident that she would respond with love and

acceptance. I caught up with Diane as she was getting in her car.

"Do you have a minute? I have something to tell you."

Puzzlement and concern crossed over Diane's face., "Sure," she said. "We're going on a hike when I get home, but I can stay for a few minutes."

"Matthew is transgender. She's taking hormones to become female," I said, mixing my gender pronouns. My bravado crumbled and tears that I thought were a thing of the past welled up in my eyes.

"How is he? — I mean she?" Diane asked. "I'm so happy for him, I mean her, that he, I mean she, is finding his, I mean her, own way." Obviously, Diane needed some time to adjust to the new pronouns, but she expressed only love for Tamara and wanted the best life for her.

Diane's response gave me the courage to reach out to others and include them in our story. It was a relief to shed the cloak of secrecy and fear of rejection. I reached out to friends outside our inner circle, speaking with each of them individually as I sought their support. Every one of them reacted with the same compassion that Diane had offered.

Later that year, Dave and I attended a wedding. At the reception, we reconnected with a couple who had moved to another town a few years before. Predictably, one of them asked, "How are the kids?" Without missing a beat, I proudly shared, "Anna's doing great. She's a freshman at the university. Matthew has a different story. He's transgender and is now a woman named Tamara. She's left school and is working full time as a night shift custodian. And she has a girlfriend!" Their faces broke out in wide grins, and they said they were happy that Matthew/Tamara was finding her true self.

Dave and I left the reception and walked down the stairs to our car, congratulating ourselves on how easily

people seemed to be accepting the news about Matthew becoming Tamara.

"Maybe they're taking the news so well because we are presenting it from a place of positivity," I said. "We're proud of Tamara. We talk about her transition as a good thing."

"I think you might be right. We aren't talking about Matthew with our heads hanging low, our eyes looking down, and muttering."

"Right. I think they're taking their cues from us. If we're happy for her, they're happy too."

MUSICAL CHAIRS

\mathcal{M}atthew and Anna had both played in the school bands from the beginning of middle school until their respective graduations from high school. Matthew played the drums and Anna played the clarinet. I attended thirty-eight formal concerts over the course of those eleven years. While I question the sanity of anyone who teaches middle school band, the dedicated teachers in our district ensure that the kids achieve a level of excellence by the time they move on to high school. The high school band director develops an unparalleled rapport with the kids, who become motivated to perform with extraordinary skill. Those first concerts sound a little warbled and off-key, but the high school upperclassmen put on concerts that carry carried you off into another place altogether.

At the end of her junior year of high school, well before Matthew revealed to us his secret, Anna returned home from the annual band camping trip with a story from the last night of the trip.

"We sat around the campfire telling funny stories about our childhoods, parents, friends, and teachers,"

Anna said. "It got pretty late and everyone else went to bed, but me and Josh kept talking. He ended up telling me he was transgender," Anna told me nonchalantly. "He's still keeping this mostly to himself but plans to 'come out' to everybody next year."

I knew Josh's mom from our years volunteering together at the kids' elementary school. "How is Josh's mom taking that the news?" I asked.

"Oh, she's fine." For Anna, Josh might just as easily have been contemplating a new hairstyle. I recognized that Josh was making a big change, but at the time I understood so little about the transgender experience and cared about as much. I only had a detached interest in her friend's situation, and his mom's.

The following fall, Josh's mom came into my classroom, having been assigned as a substitute aide. We exchanged pleasantries, and I asked her how Josh was doing.

"Josh is actually Stella now." she said.

Anna's story from the past spring popped into my head just in time. I assimilated the information and responded without missing a beat. "That's right. I think Anna mentioned something about that. How is Stella doing?"

I couldn't have known how much emotional fortitude it took for Stella's mom to navigate our conversation so smoothly. It was only later, when I joined the lonely club of parents who have transgender children, that I would understand what a minefield it can be to answer even a simple question like, "How is your child doing?"

As seniors, Anna and Stella earned seats in the honors band. The December holiday concert is always the first concert of the school year. One month had passed since Matthew came out as Tamara, and I was still overwhelmed with confusion and grief when I attended that concert

with a smile plastered on my face like a mask. I summoned as much enthusiasm as I could muster because I knew Anna deserved to have her mother emotionally present for her and I wanted to show my pride in her musical accomplishments.

The Freshman Concert Band, the youngest group, played two pieces. Then the largest group, a mix of sophomores, juniors, and seniors not in the honors band, played their two arrangements. Next was the extra-curricular jazz band performing a few upbeat Christmas carols. Finally, the honors band took the stage. Traditionally, their finale treats the audience to a stellar performance intended to send the audience off in full, glorious holiday spirit.

I sat in the darkened auditorium, comfortably nestled between my mom and Dave, drowsily listening as these amateur musicians entertained us. I hadn't slept well in the last few weeks, the kids at school were getting all amped up about Christmas, I had a lengthy list of things to do at home and school to get ready for the holidays, and I was just plain tired. The music soothed me, and I nearly drifted off to sleep. When it was time for the honors band to play, I shook my head, clearing out the cobwebs in my brain. I watched attentively as young men and women, on the cusp of adulthood, filed on to the stage.

The concert dress requirement for this band was black pants, white shirt, and bow tie for the gentlemen, and a lovely, floor length sleeveless black dress for the ladies. My eyes scanned the group for the clarinet section until I found my short, long-haired beauty sitting in the front row. Then I did my customary second visual check to find the other kids I knew. I stopped at the percussion section when I saw a very tall, muscular boy in an evening gown. *What? Was this some sort of prank?* I waited to hear someone explain the joke or deliver the punchline. However, the band began their warm-ups and performed

flawlessly. The band director made no reference to the boy in the dress. And then I realized what was going on. *Oh! This IS Stella.*

After my brief conversation with her mom earlier in the fall, I had thought Stella had completed her transition from male to female. In my mind's eye, she was presenting as a female. Fear and horror consumed me. *Is this what a transitioned transgender male-to-female looks like? Is this the best they can do? Is this what Matthew is getting into—a life of dressing in drag?* I was whispering these thoughts to Dave when we saw the family in front of us pointing and laughing at Stella. I looked across the aisle and spotted three other couples who were also pointing and whispering to each other. This was a nightmare.

Is this our future?

Are we going to be a family who, when we go out in public, will have people staring, pointing, whispering and laughing?

Are Stella's parents, also sitting in the audience, noticing the stir going on around them?

Does it bother them as much as it bothers me?

Is Stella aware of the impact her appearance is having on others?

Are her feelings hurt, or is she strong enough not to care?

On the drive home, Anna and I discussed the evening. "I saw Stella back there on the drums. I was surprised to see how much she still looked like a boy. Her arms and chest really looked more like a boy than a girl." Anna told me they had already discussed Stella's choice of concert dress in class. "Stella hasn't started hormone therapy, but she really wants to live as a female as much as she can until the therapy starts." Mr. B, the band director, let her decide how to proceed. By traditional standards, Stella seemed like a boy who was wearing a dress. "The thing is, Mom, she knows she looks like she's in drag. But she needs to feel

like her outside appearance matches how she feels inside. So, she made a conscious decision to wear the dress, even if it makes other people uncomfortable."

My perspective shifted right then. Stella wasn't a freak. Stella was a courageous young woman. Like Stella, Tamara was staying true to herself and her own needs. My own fear of social ostracism needed to take a backseat to my pride in Tamara's journey to find her authentic self.

HORMONE THERAPY

\mathcal{M}atthew, in his desire to climb out of his black hole of despair, got busy and took the next step to become Tamara, to transition MtF (male to female). He booked an intake appointment with an endocrinologist. Pragmatically, this was a positive and exciting time for Tamara. It was also a positive and exciting time for our entire family. Progress was being made.

Christmas break was only a few days away when my phone buzzed during my planning period. It was a text message from Matthew.

"I started hormones today. The happiest day of my life."

My son would grow breasts, lose upper body muscle, and experience mood swings in the coming months. How would these changes, artificially induced by prescription hormones, affect her health? Will she be able to get a job? Will she be able to find housing? Will she continue to celebrate her new identity, or will she sink under the weight of social ostracism?

Matthew craved our emotional support and needed

our financial support to transition from male to female. We wanted to respect his decision, honor his well-thought-out plan, and recognize his painful history. When we visited Keith the Counselor together, we talked about the physical aspects of what happens with hormone replacement therapy (HRT). Tamara could expect mood swings, crying for no reason, pain as breasts grow in. Basically, Matthew would re-experience puberty, but this time as Tamara.

"Tamara, it can be embarrassing to cry over sappy TV commercials. Are you ready for that?" We were in Keith's office and I was intentionally inserting what I'd hoped was a little levity.

"I'm looking forward to it," Tamara said, smiling.

For several years, Matthew had been telling me he didn't *feel* emotions. He blamed his antianxiety medications. Now I wondered if perhaps he/she was craving the estrogen her female self needed.

Staring at the screen and reading Matthew's text message, I grew less concerned about the long-term effects of hormone replacement therapy (HRT) because it was so gratifying to witness a joy in her I had not seen since childhood. I felt happy—and sad. Happy that Tamara was moving forward, sad that Matthew was getting smaller in my rearview mirror.

CUTE SHOES & A GREAT PURSE

*T*amara's physical appearance changed from a masculine body into a feminine one. Breasts developed, her weight shifted, and she went from having a robust upper body to curvy hips. Her skin softened, and her face became more contoured. Slowly, a woman was emerging.

Like me, she was afraid of social rejection and faced a difficult process of presenting her new self to the world. She explored the trappings of femininity and decided she would be herself on her own terms.

Tamara took her time getting comfortable with her new body and new persona. She presented herself publicly with a more male/androgynous look, continuing to go out without make-up and wearing her old standard wardrobe of jeans and a sweatshirt. Even though she was happy with her new body, she did not want to come out to the world until she felt like it was a fait accompli.

I labeled this period No-man's-land. Matthew was disappearing before our eyes, but there wasn't an eager young lady ready to take his place. This confused us, especially me and Anna. We embrace our femininity, and we

were ready to welcome this new girl into the sisterhood of make-up, hairstyling, nail polish, clothes, cute shoes, and great purses. That's not how it was going down. Tamara's hair grew long, but she wouldn't get it cut or styled. I bought her make-up, but it sat unopened. Eventually, Tamara replaced her boy jeans and tennis shoes with more stylish skinny jeans and Converse shoes, but she was binding and hiding her new breasts under a sweatshirt, even in the summer heat.

Anna viewed this time as an opportunity to help Tamara explore and embrace her femininity. She taught Tamara how to use hairstyling tools and how to apply make-up. When Anna pulled her eyelash curler out of her cosmetic bag and told Tamara what she would do with it, Tamara's eyes grew wide with suspicion. Anna also taught Tamara how to shave her legs. They sat next to each other on the side of the tub as Anna cautioned Tamara on the pitfalls of scraping too hard on the shins. I joined them and showed the girls the scar I still have on my ankle from a messy incident over thirty years ago. Anna rolled up her jeans to showcase the scar on her knee.

Despite our tutoring, Tamara limited her physical expressions of femininity to just these few moments at home, or in the privacy of her apartment. Tamara seemed to float through the year as neither a man nor a woman. We took our cues from her. When she asked us to call her Tamara, we did. Initially, only us, her family, could call her Tamara. At work, on social media and legal documents, she was still Matthew.

Matthew was undergoing a metamorphosis physically, hormonally, and emotionally. It made sense that there would be a period where he/she would live as neither man nor woman. It wasn't quite like flipping a switch. Something more subtle was happening, too. Her declaration of the desire to wear women's clothes when we were at the

pizza restaurant gave me hope that happiness was within her reach. Tamara became more soft-spoken and less argumentative with me. Tamara treated us to the sound of her laughter whenever we saw her.

As Tamara's appearance became more woman-like, Anna and I became a little frustrated that she was staying so firmly in the "I'll come out when I'm all the way transitioned" camp. We were thinking, *How much more do you need to do?* She needed to get her hair styled and cut the split ends. She wouldn't do it. She told me she wanted laser treatment to remove facial hair, so I purchased a gift certificate from an LGBTQ-friendly salon as her a birthday present. The certificate remained unused.

That spring was a strange time for us. We would sometimes slip up and call her Matthew, and sometimes we would feel like we still had Matthew with us for a few moments. Despite our efforts to use feminine pronouns and her new name, it often felt awkward. Tamara wasn't ready to change her legal identity yet, and I worried that the male name she used to register for classes would confuse the college professors when they saw this young woman sitting in the lecture hall.

By summer I had settled into the possibility that No-man's-land might be Tamara's permanent residence. But she surprised me one summer evening when she dropped by for a visit. Tamara had shed her sweatshirt and was wearing a dressy woman's shirt with a bra underneath. Anna seized the moment and offered to pluck Tamara's eyebrows. It flabbergasted me to hear Tamara agree with the plan. Tamara continued to experiment with feminine clothes and women's grooming habits. It seemed as if No-man's-land was a thing of the past.

Tamara tried out her new identity with a larger audience precisely one year after coming out to the whole family. It was another Thanksgiving. She arrived at our

house wearing a lovely blouse, dress pants, cute shoes, and sporting a simple new hairstyle. She asked Anna to help her apply make-up. They crammed themselves into the tiny bathroom and spread their compacts and brushes all over the counter. I wanted to insert myself into this process, but it quickly became obvious that I would get in the way of a special moment between sisters. *How many girls get to say that they helped their trans sister do her first make-up on the day she came out to the world?* Periodically, I'd hear a burst of giggles and I'd pop my head in. "What happened?" In unison, they'd answer, "Oh, nothing."

Tamara emerged as a beautiful young woman with poise. She was so proud of her new look that when her great-aunt asked her how she was doing, she waved her arm over her body and said, "I don't know if you've noticed, but I've made some changes." *As if the changes could have gone unnoticed.*

This was the day Tamara changed her name from Matthew on social media. When she got home from Thanksgiving dinner, she posted the picture I had taken of her earlier in the day.

Tamara was becoming more comfortable letting others in on her transition. And I was becoming more comfortable using the pronouns "she" and "her" when referring to Tamara.

The transition from male to female was nearly complete.

CAMPAIGN OF PRETENSE

*M*y fog was lifting. I entered a coping phase, taking the adage "fake it 'till you make it" to heart. I was consciously launching what I call my Campaign of Pretense.

"How are you doing?" Such a simple question, yet my answer, during that first year, was complicated. My response depended on who was asking, how much time I had, and whether I sensed the person asking wanted my honest answer or a platitude. *Should I put on my Campaign of Pretense persona, or could I delve into the deeper, more treacherous territory of honesty?* Platitudes were easier.

"I'm fine."

"We're doing okay."

"It's been tough, but we're doing pretty good."

If I wanted to go a little deeper, I could still get the words out fluently.

"It's been hard for Dave and me, but we're getting through."

Deflection worked well in some situations.

"We're good. Our oldest is at school, working to

become a video game programmer and loves it there. Our youngest is a senior in high school—can you believe it?"

"Things are all right. How are your kids doing?"

Honesty, however, meant divulging my innermost feelings, which required time and the full attention of the person receiving my answer.

I found the search for *truth* in my life complicated and difficult. I was processing emotions and thoughts that consumed nearly all my mental energy. I was reconciling the loss of Matthew while working on accepting and appreciating all that Tamara would bring to us.

It was like peeling back the layers of an onion. I believed that when I'd shed enough tears, I would find acceptance, joy, and appreciation for the new life Tamara breathed into our family. Each layer, however, was laden with issues for me to identify, name, and wrestle with as I tried to discover their meaning, nuances, and implications.

The layers in my onion of grief included loss, isolation, and fear. My heart ached with the loss of the son I thought I knew. I wrestled with questions about our family identity and realized that even the most well-meaning family members and friends could not relate to my experience. I feared for Tamara's safety in a political climate where our country had recently elected a president who didn't seem to have any tolerance for LGBTQ issues and whose supporters were growing bolder (and sometimes more violent) by the day. And I worried about the impact her transition would have on her and our family.

The only thing that could pull me away from my constant obsession over losing Matthew and the worry about Tamara's future was to replace my focus with something else that would keep me too busy to dwell much on those thoughts. I immersed myself in my work. I worked nearly all the time. I was the first person in the door, and the last to leave. I often stayed at school until the heat

turned off, and it became too cold to stay any longer. I worked after dinner, reclining on the couch, pounding on the keyboard until my eyes drooped. I got a lot done. My lesson plans were creative and thorough, I wrote unit plans that could have sold on the open market. I developed worksheets that rivaled what curriculum companies produce, and I graded papers with a meticulous eye for detail. It wasn't necessarily a healthy coping strategy, but for the time being, work was the only way I could keep myself moving forward.

The Campaign of Pretense permeated my interactions with Tamara through the first few months of the transition into her female body, giving birth to a voice whispering in my ear.

"Let's make a deal."

"If you love her enough, she'll stay alive."

"If you buy her girl things, she won't want to harm herself."

I bought women's clothes, makeup, brushes, ponytail bands, women's razors, lotions—anything I could think of that might make her transition easier. I reasoned that if I bought the *right* girl stuff and taught her how to use it, everything would be okay. I was bargaining. *If I do these things (be a good mom) there will be a positive outcome (Tamara will be happy, healthy, and whole).* While my logic was flawed, bargaining was part of my progression towards acceptance.

Once Tamara started going through HRT, I asked her to come home for Sunday dinner every week so the changes wouldn't be as dramatic (and traumatic) as they'd be if we only saw her sporadically. Four weeks into her transition, Tamara arrived and followed the usual routine of greeting the dog with enthusiastic petting, hugging Dave, and giving me a kiss hello. I had gone on another shopping spree that week and handed Tamara a bag with a

new hairbrush, bobby pins, and ponytail bands. Anna motioned for Tamara to sit down on the floor in front of her spot on the couch and to bring the bag of goodies.

Split pea soup was on the Sunday night menu, and it was safely simmering on the stove. I had a few minutes to spend with my girls before serving dinner. *With my girls.* I sat next to my two daughters and watched my youngest brush out her sister's long hair. I couldn't recall seeing them interact in such an intimate way.

Anna played with different hairstyles: French braids, messy buns, side ponytails, a high pony. Some results had us howling with laughter. Finally, she got serious and taught Tamara the finer points of how to make a simple ponytail, even explaining how a bobby pin goes in your hair with the bumpy side down. I covered my mouth in awe. "Tamara, you look so beautiful. I can't believe how much you look like Anna right now!" I saw a light in Tamara's eyes, and she flashed me an easy smile. Something I hadn't seen in a very long time.

My children talked and laughed that Sunday, and Tamara was more relaxed than I had seen her in years. Her potential beauty as a woman was evident. It struck me then. There was cause for joy in this tableau.

Perhaps I didn't need to pretend quite as much anymore.

THE WALL COMES DOWN

*O*n Christmas Eve, Tamara arrived in the afternoon with an overnight bag, expecting excellent food, a stuffed stocking, gifts under the tree, and family time. She dropped her bag on the guest bed and turned as I walked down the hallway to greet her.

When we moved to this downsized house, we needed to downsize the picture wall too. I chose my favorite photos to put up on a single wall of the guest room. As I watched Tamara unpack her things, it seemed as if that wall had eyes glaring at me. Half of the pictures on that wall were from her boyhood. And about half of those were from her teen years.

I ignored the glare, turned on my heels, and headed back to the safety of the kitchen, carrying on with preparations for the big family dinner I would host the next day. For me, ironing is a solitary activity that gives me time to think. As each napkin transformed from a crumpled ball into a crisply folded addition to the table setting, the message from the glaring eyeballs of the picture wall became clear.

A conversation from earlier in December echoed in

my mind. "You're telling me you've felt this way for years. What made you come out now?"

"My body started going through the last stages of puberty. Every experience I've had with my body changing into a man has made me feel worse. When I look at pictures of myself from those times, I hate myself even more."

Tamara would sleep in that room. I cracked the code. The picture wall was telling me it was unkind to ask Tamara to be a guest in a room where there would be so many blatant reminders of a past she loathed. I gulped down my self-interest and felt generosity filling the space. The pictures from her teen years would need to go—that's when the gender dysphoria began. Of course.

"Tamara, if you want to take down the pictures that make you uncomfortable in the guest room, go ahead. I want you to always feel at home here."

The table, with three leaves added in, consumed nearly half the living room in our small house, adorned as it had been every year with a freshly ironed tablecloth and napkins, crystal glasses, Christmas plates, and polished silver, awaiting the Christmas feast. Dinner on Christmas Eve, though, is a far simpler tradition. After a full day of preparations and in anticipation of a full day as a hostess, I took the night off from real cooking, and we enjoyed takeout pizza with a pre-made salad from the grocery store while eating on the living room furniture. Dinner ended and everyone scattered to do their own thing. They left me to wash the few dishes we had dirtied.

As I was finishing, I heard strange thumping noises coming from the guest room. I wiped my soapy hands on my jeans and went to check out what was going on. Turning the corner into the hall, it seemed as if I was in a vacuum; the air sucked out of the room. I couldn't breathe. I stood there for what felt like an eternity as I

struggled to engage in the scene. Tamara had removed every picture of Matthew. *Wait! What? This was not what I intended.* I had told her she could take down the teenager pictures—the ones that marked the beginnings of her gender dysphoria—not *all* the pictures. In the middle of a growing pile of pictures and frames, lying face up on the floor, was a picture of my adorable two-year-old boy, wearing shorts of green plaid and suspenders and clutching his stuffed frog. Tamara grinned, then stooped to stack the discards of Matthew's childhood neatly on the floor. To her, the picture wall told a different story.

The story of a battle.

As I played back the mental recording of what I'd actually said to Tamara in the kitchen, I realized I had, in fact, told her to take down the pictures that made her uncomfortable. Tamara needed to ensure that Matthew no longer existed in any way connected to her. Taking those pictures down was a tangible way to leave Matthew behind, letting us know that she never wanted to look back. This was a critical phase of her journey to embrace her newly acknowledged self, but I struggled with the desire she had for the rest of us to erase her childhood.

Torn once again by the conflicting interests of Tamara's efforts to carve out a new identity with my desire to hold on to symbols and memories of the past, my relationship with the picture wall was deeply damaged. The wall wasn't staring at me now. I was staring at it—in horror. Gaping pockmarked empty spaces seemed to dwarf the remaining pictures of Dave, Anna, and me.

Standing by the doorway, disconnected from the wall I'd treasured for so many years, I knew what I needed to do. A family picture wall devoid of a family member would only make me feel a greater sense of loss and sadness. If we left the picture wall this way, even if we rearranged the remaining pictures to cover the gaps, a

picture wall without Matthew would always feel incomplete. It would no longer infuse me with joy over happy memories.

Aware that something was happening in the room next door, Anna emerged from her nest to assess the situation. First, she saw the wall, but didn't register what exactly had happened until she looked me in the eye. "Oh, Mom!"

I caught my breath, finally able to talk. "It's okay. I told her she could do it." Turning to Tamara, I said, "I didn't think you'd take down *all* the pictures of you." Tamara shrugged, grabbed her phone, and went to the living room to pass the evening.

Anna, still standing next to me, put an arm around my shoulders as we surveyed the carnage together. "Will you help me take the rest of them down?" I whispered. We finished the job quickly and the picture wall was just a wall. I packed the pictures, making plans to remove them from their frames and do . . . something . . . with them later.

"Matthew doesn't want his pictures up," said Anna, "but what about mine?"

"My bedroom is my sanctuary," I said. "I can keep what I want in there. Pick two of your favorites, and I'll display them in my room."

I was losing my tenuous hold on Matthew's childhood experiences, but I hoped that, someday, Tamara would reconsider and want the memories preserved in boxes and scrapbooks. Maybe, someday, she'd want to hear the stories behind the pictures again. But it seemed I was the only one who found comfort in them.

My thoughts circled around this drain for several more months.

WHAT WAS REAL?

 amara shed her old name and male gender pronouns like a snake sheds its skin. One Sunday evening in March, after we all had buttered our biscuits and were blowing on our spoons full of steaming vegetable soup, I started the evening's conversation. I asked Tamara, "Did you register for next quarter's classes yet?"

"Yeah, but it was awful."

"Oh no. What happened?"

Tamara clenched her jaw and mumbled, "The lady there kept using my dead name."

"Your what?"

"My dead name. They have all the forms I filled out where they asked me for my preferred name. There's no reason she had to keep using my dead name."

My heart skipped a beat, and I sucked in a deep breath hearing her refer to her dead name or dead life. Tamara's voice was hard, indignation bordering on anger. My confusion morphed into understanding. Matthew was dead. This was about more than the name. In Tamara's mind, Matthew's entire identity was dead. Tamara had left

Matthew behind, and she expected everyone around her to leave him behind too.

~

Turning the pages of the heavy scrapbook on my lap, I grappled with conflicting evidence. I had physical evidence, multitudes of pictures lovingly pasted into scrapbook volumes and those that had once told a story on our wall, that a young boy was integral to our family identity. That boy was now "dead," according to Tamara, which was the contradictory evidence impossible to ignore.

As Matthew transitioned into Tamara, our family identity changed too. I flipped another page. I questioned my role as this person's mother. I dwelled on Matthew's childhood.

What was real in the twenty years of our family's story? Did the boy in these pictures harbor an internal life and the camera didn't see—that I, his mother, didn't see? When did it change for him? Or was it always this way?

My memories and stories featured Matthew as I perceived him. I happily cheered him on as he marched with intense concentration in parades carrying cymbals as large as his entire torso. I proudly sat at the robotics team awards dinner and watched him, attired in the team's neon splatter-painted shirt and pants, sporting an extra wide grin, drive their newly constructed robot. I recorded every birthday with a picture of him blowing out candles on cakes, each year celebrating another milestone on his journey into manhood.

Now, a lump formed in my throat when I studied those pictures. What he was he thinking? What didn't I understand about what was happening in those moments? Do these pictures accurately represent what was going on?

If he wasn't having fun, like I thought he was, were any of us having fun?

I was back to the original question: *What was real?*

This internal dialogue was too much for me to handle alone. I reached out to my friends. I tried to transform the jumble of thoughts into a coherent set of spoken words.

"I don't know what was real," I said. "It seems like nothing is what I thought it was. Was it all an act? How far back does that go? Was Matthew ever who we thought he was?"

One friend responded dismissively. "It was all real." I hadn't expected her to solve the riddles, but I had hoped she'd acknowledge my anguish.

Another friend stared back at me, confused, and said nothing. These were women who were an integral part of my support system. I knew they loved me, and that they wanted to help me, but I realized they couldn't identify with this dimension of my pain. They had no frame of reference. How could they? I would have to tackle these questions alone, in what felt like a repeat performance of those early years when I kept our struggles with Matthew hidden from public view. I felt alone on this journey, investing most of my emotional energy in reconciling what I saw as two very different worlds.

On the outside, I returned to living my life normally, as I always had. However, on the inside, another strange life was playing itself out. I began identifying myself as a trans-parent, an oxymoron, since I was anything but transparent.

What. Was. Real?

I explored the authenticity of the relationships within our nuclear family. From my perspective, we were four people who had lived, worked, loved, cried, laughed, ate, worshipped, argued, and played together for twenty years. However, by her words and actions, Tamara was telling us

she took part in that dynamic under duress and her own campaign of pretense. My reflections went deeper.

Who was the person with us?

Did Matthew like playing drums in the band?

Was his experience with the robotics team as fulfilling as it seemed?

Did Matthew fall into roles associated with being a boy with Asperger's syndrome because we expected him to? Was it easier to play the part?

What role did I play in his double life?

Was I responsible for his anguish?

Tamara was sorting through what was real in her own inner life as she transitioned from male to female. While it wasn't enough to declare Matthew dead, to her credit, she recognized that I needed her help to understand why she needed to erase Matthew.

Tamara explained that, as Matthew, his sexual identity confused him, as sometimes he found both boys and girls attractive. I didn't find that particularly surprising, since most teens explore their sexuality as they move through puberty. But she also told me she'd fished women's clothing catalogues out of the garbage and flipped straight to the pages with lingerie models. She said it wasn't that the models were attractive to him. Instead, she dreamt about being someone who could wear the items. Matthew asked his therapist questions about sexual identity. Unfortunately, the therapist shut him down, telling him he was too young to discern his sexual identity.

Tamara told me that Matthew would wake each morning filled with dread. Tamara gave us increasingly descriptive glimpses into Matthew's teenage world, leaving me to revise our narrative into a more detailed picture that was far darker than I'd imagined. Matthew's pent up anger and withdrawal made more sense the more I learned. He

had lived his life feeling shame over his secrets, locking them securely in his interior world.

I began to understand why Tamara wanted to bury Matthew's secrets and pain. But I still couldn't shake the feeling that my narrative of our family's life together was false, or at the very least, it was incomplete, fuzzy, as though twisting the center adjustment on a pair of binoculars and never finding the setting to bring the distance into focus.

It was a warm summer evening when Tamara joined us for a light supper of pasta salad. We ate outside on the patio, and I reminisced about other warm summer days when Matthew was a young teen. "Remember that summer when you, me, and Anna spent long days at the camping club with Uncle Jim and your cousin Ryan, and you kids would go swimming in the pool? You guys would laugh and play in the water while Uncle Jim taught me how to play Dominion. It took me nearly all summer to master that game, but it was so much fun." I was about to run into the house to retrieve the album and find the pictures of those fun summer days when a shadow passed over Tamara's face.

I sat back down in my deck chair and raised my eyebrows, silently asking her to share her thoughts.

"I wasn't really having that much fun. I went because you made me go," she mumbled.

"What? You were jumping into the water with abandon, you were having fun with Anna and Ryan."

Tamara lowered her eyes. "I was in swimming trunks. In public."

Understanding washed over me, and with that, the happy memory I'd had of our sunny summer afternoons dissolved. In its place I felt Matthew's discomfort, being out in public with his bare torso on full display, wishing he could cover his breasts in swimsuit tops like the rest of

the girls. We both remember the experience. Differently. We each have our own perspective.

What.

Was.

Real?

DISCRIMI-NATION

*T*amara was vigilant about researching side effects and potential interactions involved in taking her prescribed medicines. She seemed to have a firm understanding on what she was doing as far as the physical aspects of transitioning from one gender to another. She also left the university, enrolled in a local community college, secured a job, and rented an apartment.

She researched her legal rights as a minority in our state. She explained to me how our state's freedom from discrimination law specifically protects vulnerable citizens from acts of discrimination when seeking employment, housing, or entry to public events. This law explicitly includes sex and sexual orientation in its list of protected groups.

The law seemed to work, but I still worried about how others would treat her. *Will there be people who would rather hurt her (or even kill her) than face their fears about something they don't understand?*

I had heard about hate crimes where people had been beaten or killed. Bathroom wars became a thing. That's when groups lobby for laws to prohibit transgender people

from using the public restrooms reserved for the gender with which they identify. Their tactics to raise support for their cause range from public shaming to suppositions of potential sexual abuse to media campaigns. I read articles that referenced anecdotal evidence suggesting a large percentage of transgendered people come to regret their decision to transition.

Tamara shared details of encounters. They gave shape to my fears, and I suspected she didn't tell me everything. She told us humiliating stories of people hurling homophobic slurs as they pass, Christian leaders who openly snub her, and potential employers discriminating against her and rejecting her.

Our society values conformity to certain standards. As a transgender person, Tamara stands out as being *other*. When Tamara was working at a supermarket, stares of confusion infused customer interactions as people tried to figure out if she was a boy or a girl. I understood what Tamara had been telling me about this phenomenon when she sat with me on the sidewalk lining the Fourth of July parade route that runs through our downtown thoroughfare. An acquaintance I hadn't seen in years was passing out a political flyer, and I called out to her so I could say a quick hello. Her face lit up when she recognized me, then a shadow passed over as her gaze landed on Tamara, the puzzled stare long enough to make Tamara and me uncomfortable.

We recently asked Tamara to look after Mila and the house while we took a brief vacation. She agreed, willing to make the long commute to work, excited to spread out in a space bigger than her studio apartment. As she walked Mila one afternoon, a truck full of teenagers slowly drove by yelling, "Hey, tranny . . ." She changed her routine to walking the dog after dark.

Tamara endures sexual harassment at work—lewd

comments or jabs at her sexual identity. When she goes through the security checkpoint at the airport, she is automatically identified as *other*, and must submit to a pat down search that includes touching her genital area (over clothes, fortunately, but still).

Dave and Tamara have a standing breakfast date every Thursday at a restaurant near their places of employment. Being regulars, they have a booth they claim as their own, and Julie is the waitress that serves them. Julie is always happy to see them, and if they miss a week, she'll ask if everything is okay. I joined them once, and Julie seemed delighted to meet me. This breakfast they share, along with the sense of belonging, is an uplifting experience for Tamara. However, while visiting us one Friday evening, Tamara disclosed a darker side of these mornings. "There are pastors that meet at the restaurant on Thursday mornings," she said. "They normally sit at a big table close to us. Yesterday morning, they took their coffee cups and moved to a table on the other side of the room."

"Maybe they just wanted to discuss something private and moved to where others couldn't hear them," I offered.

"I wanted to think that too, but the booths right next to them were full of other people. I hate to think the worst of them, but it really seemed like they wanted to get away from me."

Tamara eventually abandoned academics and took a full-time job as a custodian at a mall, working the night shift. Before she could work her first shift, her employer required drug testing. An outside company would administer and process the test. Tamara knew her test would be clear, so she wasn't anxious about that. However, she soon discovered that rules required a company employee to supervise the collection of the urine specimen. Tamara asked if a woman could be present for her test, but the manager refused. In his mind, anyone with a penis was a

man and therefore a man would supervise. True, Tamara still had a penis. But she identifies as a woman, and she didn't—doesn't—want a man to watch her urinate. She wanted the job more than she wanted to protest their ignorance of what it means to be transgender, so she did not storm out. She thought about reporting these people to the governing council responsible for discrimination complaints. But she hadn't yet legally changed her gender, or her name, and she didn't want to do anything that would delay her ability to begin work. She did as asked.

Every new story Tamara shared with us reinforced the fears I carried with me. Each time I heard a new installment of Tamara's experience, I had to tap into what I learned that December night at the concert. Stella was compelled to live out her true identity, knowing her decision to wear a dress might come at the cost of social acceptance.

Tamara's decision to live authentically comes at the same price.

SECTION III: THEIR MOTHER

HELLO EMPATHY

*W*eather forecasters were predicting a snowstorm, and Tamara was eager to get on the road as soon as we finished our Sunday dinner. Dave and I were cleaning in the kitchen when Tamara came in to talk with us. "You remember Alex and Brian from high school?"

Um, not really, but I don't want to shut down this conversation. "Sure," I replied.

"Alex lives with his aunt and she's sick. Like maybe even dying. She's his whole family. And Brian is really depressed about how he can't make enough money at his job to support himself, and his parents won't let him move back in with them."

I didn't know what to say other than, "Wow. That's so sad."

"I know. It makes me sad, and I'm also worried about them."

There wasn't much more to say, and Tamara packed the leftovers and took them home with her. After she left, our kitchen conversation tickled my mind like an itch that needed to be scratched. *Why do I feel like something signifi-*

cant happened? As I was brushing my teeth before bed, it hit me.

Tamara was expressing empathy. And concern for friends. This was new. Matthew had always struggled with emotions like empathy.

Winter melted into spring, and Tamara fell in love with another transgender woman. She brought Shelly to our house for dinner one Sunday in May. They were obviously quite smitten with each other, holding hands under the table, Tamara nestling her head on Shelly's shoulder, and occasionally exchanging a quick kiss. After dinner, we played a game. Poor Shelly, she was thoroughly unprepared for the intensely competitive beasts that emerge out of every member of the Gibbs family when we play games. One particularly cutthroat move between Tamara and Anna started a shouting match. Shelly's eyes grew wide and her mouth hung open, unsure of what was happening. When Tamara saw Shelly's face, she threw her head back laughing, a belly laugh that I hadn't heard in nearly fifteen years. She reassured Shelly that she and Anna were not angry; they were having fun with each other. For the first time since she was a very young child, I knew what I was seeing was real.

Tamara was experiencing joy and happiness.

DEGREE OF BEING

*T*amara picked Dave up at the office for their weekly breakfast get together. A coworker of Dave's walked past them as they were getting into the car. To his office buddy, Dave said, "This is my daughter, Tamara."

The car ride was quiet, which wasn't unusual. Tamara often passed her time in silence, so Dave thought nothing of it. Once seated at their regular table in the restaurant, Julie poured Dave and Tamara each a steaming cup of coffee.

"Please stop calling me your daughter, Dad." There was a new directness in her eyes. Dave's coffee cup froze on its path to his lips. "I'm actually nonbinary," she said. Dave looked at Tamara blankly. "I'm not really either male or female."

"What should I call you then?"

"Just introduce me as your kid. You can still use *she* and *her* if you really want to. I don't see myself as either of the traditional genders, but I identify more as a female than male."

Dave recounted this conversation while we ate our

Caesar salads that evening. I let out an abrupt laugh. Maybe more like a snort.

"Huh?" I set my fork down on the plate and rested my chin in my palms.

Dave grinned, "I know, right?"

"I know this is important for her, but really?" I shook my head. "She has a woman's body now. How are we *not* supposed to call her our daughter?"

Nonbinary. My thoughts zipped me back to my school years, not my teaching years, but when I was a young student. Binary means double, dual, when a thing can be split into two categories. Black and white. Dark and light. Male and female. So, nonbinary is not this dual thing.

"Nonbinary," said Dave. He seemed to try the word out.

"Nonbinary," I echoed back. "Not one or the other, but a degree of being?"

This would take us more time to adjust. We'd just gotten the hang of having a daughter, not having to work so hard to remember to say "her" and "she."

"I had no idea how much this issue means changing how we use the English language," Dave said, getting up and taking his empty plate to the sink.

Yes, and this was beyond language usage. I would have to reframe my understanding of Tamara once again. She was introducing yet another new dimension to her—and our—transgender experience.

This time, however, felt different. I didn't feel the same emotionally charged reaction, the way I had when Matthew first came out to us. I gratefully noted I was better able to separate the things she was responsible for in her own life, including decisions about her identity, without feeling like it was upending everything in my world.

I noticed that Tamara posted several memes on social

media about how people should use the pronouns they, them, and their when referring to nonbinary people. *I can take a hint.* Just as I was finally fluent with "she" and "her." But I could adapt.

I'd proven that.

GENDER X

amara and Shelly split up after a huge argument. Tamara appeared at our front door with her luggage—a large garbage bag stuffed with clothes and a toothbrush. I lay next to her on the guest bed and listened to her pour out the pain of her first broken heart. Over the weekend, she and Dave went to the apartment she'd shared with Shelly and moved her remaining belongings. It was final. The relationship was over.

Tamara was desolate. She was on her own now, financially and socially independent. She abandoned some of the more obvious trappings of her female persona. It seemed she wore the dressy women's clothes and makeup for Shelly. She went back to wearing her former uniform of jeans and a sweatshirt. But she kept her hair long, wearing it pulled back in a ponytail, and she continued with her hormone replacement therapy to keep her female physique.

I thought Tamara would find life easier if her legal documents, like her driver's license, had an updated picture, her female name, and corresponding gender marker. Wouldn't this reduce the confusion of potential

employers over her gender identity and help her find a better job? But Tamara would not begin changing her name and gender on legal documents.

I worried the reluctance might be depression-related inertia, but I kept my opinions to myself, repeating a new mantra in my head. *She's an adult, making her own adult decisions, and it's not my place to intervene.*

A year after the breakup, Tamara walked into the courthouse to petition the court for permission to change her name legally to Tamara Riley Gibbs. She walked out with a signed order approving her request. She sent me a photo of the order, followed by a smiling emoji. I couldn't help but smile too.

By the end of the week, she called me asking for my social security number as well as Dave's.

"What do you need them for?" I asked, mindlessly fishing around in my purse for the key to our bank safety deposit box.

"Now that I have the court order to change my name, I'm filling out the application to change my name and gender on my birth certificate."

When a transgender person changes their legal documents to reflect a new name and gender, the new birth certificate replaces the original. I made this discovery in the first few months after Matthew came out to us, and it threw me further into the abyss of my despair. It seemed unnecessarily cruel to the mothers who delivered these babies to so casually change the official record of such a momentous event, like bringing a new life into the world. Wasn't this playing with the truth? The capital T Truth?

Regardless, here we were. There would no longer be a legal record that Matthew Gibbs, a male, was born. The only record of his birth, as it really happened, would exist tucked away in my closet with a box of blue baby clothes and other mementos.

She's an adult, making her own decisions, and it's not my place to intervene.

Huh. Apparently, I'd had enough time to process my emotional response to Tamara's transition, and I was responding in a healthier, more joyful way.

Three weeks later, Tamara arrived for Friday family game night bursting with news. She proudly pulled her freshly printed state sealed birth certificate out of her coat pocket. Seeing her so excited made it impossible for me to cry. Tamara was happy, and that's all I'd ever wanted for her. I felt a slight tug of nostalgia for the baby boy I'd had, but I put that away and instead focused on this precious moment. A different sort of milestone for the same child.

We sat at the kitchen table to look at this addition to the family. A smile crossed my face as I read my name and Dave's, with our own birthdates, still listed as the parents, directly under the state's seal. I continued reading to see the name Tamara Riley Gibbs printed on the next line.

Below that, the box for gender was marked with an X. Pointing to it, I looked up at Tamara. "What's this?"

"Ours is one of the few states to add a third gender choice. Not just male or female."

Remembering the recent exploration of the meaning of nonbinary, I was feeling proud that I was getting it.

"Okay. So . . . you're legally nonbinary, not any gender at all?"

"Not exactly, Mom. Gender X covers all ranges of sexual identification: pansexual, gender fluid, nonbinary . . ." As she trailed off, she flipped her palm upward in the universal *you see?* gesture, eye roll included.

Dave brought out a jug of iced tea and poured each of us a glass. We toasted to Tamara Riley Gibbs, who won both of the games we played that night. Dave and I made a pact. Respecting Tamara's change of legal identity, we

committed ourselves to referring to our child as **them** or **they** at all times.

This formerly procrastinating Matthew was on a roll. Next, Tamara downloaded the application to change **their** name with the Social Security Administration. When **they** called me this time, **they** had a different question. "The form says to fill in the gender box with an M or an F. What should I do?"

"Well, why don't you just write an X?"

"But it clearly says to fill in either M or F."

"How about using an F since that's the gender you most identify with?" I looked down to notice I had written a capital M and an F with a huge question mark between them. I drew messy circles around them.

"But then it won't match the gender on my birth certificate. And I have to send a copy of my new birth certificate with the application. To put an F would make me guilty of perjury."

Oh my, this really has **them** *in a spiral.* "I don't know honey, what do you think? You could try calling the Social Security office, if you can get through to a live person."

I heard **them** sigh and sensed another eye roll. We said goodbye and hung up.

They had called asking for my advice but hadn't really liked my answers. Or perhaps **they** just weren't used to this new type of response from **their** mother. My usual modus operandi would be to either explain why my answers are viable, or to keep offering more answers. Things had changed, for me and for our relationship. I found I was okay with giving **them** my honest opinion. And then leaving it alone.

They're an adult, making **their** *own decisions, and it's not my place to intervene.*

Tamara's concern for doing things right, in this case wanting to be sure the gender marker on **their** driver's

license matched **their** social security card, bumped against bureaucracy. The state's recognition of a neutral gender identifier was at odds with the federal government's requirements. After a few futile attempts, **they** gave up trying to contact the Social Security office and finally wrote an F in the box.

Tamara's work schedule changed, and now **they** visit on Saturday evenings instead of Friday. Dinner is usually casual, takeout. We still play a game after dinner, and it's uncanny how **they** win nearly every game. It's a pleasure to have **them** over, and our relationship is much more relaxed.

When **they** were a child, I was **their** mother in a very interactive and protective way. I often felt **their** behavior reflected on me, and **they** were proclaiming to the world that I was a terrible parent. Now, I am comfortable letting Tamara live **their** life on **their** terms. **They** are an adult, making **their** own decisions, and it's not my place to intervene.

(Author's note: I originally typed every "they," "them," and "their" in the above paragraph as "she" or "her" before I caught the nonbinary pronoun misnomer. It's a mindset shift that I'm working on.)

A MOTHER WORRIES

*T*amara shared a story with me about a time when **they** drank so much that, rather than delivering the desired soothing effect **they** sought, it fueled their self-loathing to the point of trying to end **their** life by choking **themself** with a belt. Although **they** were unsuccessful on this occasion, **they** tried again three days later. **They** changed **their** mind in time to remove the belt from **their** neck, pour the contents of the whiskey bottle down the drain, and call a helpline. The suicide helpline volunteer talked **them** through the urgency of the moment and convinced **them** to call 9-1-1. Tamara admitted **themself** for psychiatric treatment, which is when I learned about the previous week's events, and how intensely **they** felt loneliness, isolation, and victimized every day. It's also when the latest in Tamara's string of diagnoses appeared: borderline personality disorder.

My emotional response to Tamara being suicidal this time differed from the first time, when I learned during the family session with Keith the Counselor that Matthew wanted to end the pain of living. This time, I didn't let my fear for **them** paralyze me. Tamara's sense of despair deeply

saddened me, and I worried that **they** would always need to fight this battle. But now, I understood that this wasn't about me.

It was about Tamara, and how **they** were coping with the unrelenting negative attention thrust upon **them.** Tamara often takes the edge off of the pain with alcohol.

It's Tamara's job to work on improving **their** mental health, and it's my job to support **them.** Tamara still meets with Keith the Counselor every Thursday, and he is working to help Tamara develop better coping skills. Tamara sees an endocrinologist who frequently checks **their** hormone levels to ensure a healthy balance. The hospital added a psychiatrist to **their** medical team, who prescribes and monitors medications that help stabilize **their** emotional reactions to triggering events.

Still, I worry. The worry I had about young Matthew's future morphed into a different sort of worry with Tamara. The worries I have for Tamara are for **their** safety and mental health as **they** face the hardships associated with living as a queer, nonbinary person.

Tamara lives in a part of a large city with a sizeable population of LGBTQ citizens. Hate crimes and bathroom war incidents happen far less in **their** area than other parts of the country, although they happen. Still, **they** feel relatively safe in their neighborhood. Here in our small town, where **they** grew up, **the** people who have known **them,** and our family, accept **them.** But otherwise **they've** been subject to enough verbal abuse and glares (and worse) that when **they** come back home to stay with us, **they** don't venture outside. I appreciate **their** caution when **they** are here, but I worry that **they** have a false sense of security about **their** safety in the city. It's heartbreaking and scary to think about the risks my child takes every time **they** go out.

In my heart, I wanted to support Tamara's transition fully, but I was concerned **they** would regret it later.

"How do you know you won't go from being a depressed Matthew to being a depressed Tamara?" I'd asked Matthew early on.

There's no guarantee that Tamara will always be satisfied with **their** decision, but **they** seem content with it now, which makes me worry a little less about **their** future.

The COVID-19 pandemic is testing Tamara's ability to handle extreme stress, and it is also testing my commitment to resist the urge to drown in worry about **them**. The pandemic is a ruthless enemy to Tamara's fragile mental health. **Their** routines are disrupted. The media is flooded with fear-inducing stories of extreme outcomes which fuel a pervasive fear for **them** I would contract the virus and die (my current health issues put me firmly in the high-risk category). **They** remained employed during the first week of the stay-at-home order, which had the potential to help keep Tamara stable. Unfortunately, the assigned tasks included using a small scrub brush to sanitize every step of the mall's escalators, leaving **them** demoralized, ripping the knees of **their** pants, and scraping layers of skin.

I worried Tamara was unraveling alongside the unraveling of our social infrastructure. Every fiber of my being wanted to beg **them** to come home and self-isolate with us for the duration of our state's mandated stay-at-home order. My maternal instincts insisted I keep **them** with me and protect **them**. Instead, I restrained myself and texted **them** a few times each week to check in.

Mostly, **they** did well—for the first few weeks. **They** went to work until **they** were furloughed (with pay). **They** grocery shopped and cleaned **their** apartment. Then the phone rang, and it was Tamara asking me a question.

"I want to know if you can help me find a lawyer so I can sue my doctor."

What? "Why, what's happened?"

Tamara's voice increased an octave as **they** became more emotional. "I was telling a friend what medicines I take, and she freaked out on me. She says two of these drugs cause a lethal reaction when taken together. I could have died. I want to make sure the doctor never does that again to anyone else. I was hoping you would help me find a lawyer who deals with medical malpractice suits."

Offering a voice of reason, I suggested that perhaps more research might be warranted before moving ahead with a lawsuit.

Their voice went to a pitch I recognized from Matthew's childhood, the foreshadowing of a complete meltdown. "I don't want to talk about that part. I'm asking if you can help me find a lawyer."

I calmly agreed to look into it for **them**.

I hung up the phone to see Dave standing at the doorway with his eyebrows raised and his hands open to the ceiling. "What was that about?"

As I relayed the story, Dave slowly shook his head with empathy.

Looking under the surface of our phone conversation, I recognized that Tamara was using a coping strategy for **their** emotional distress that **they** have used since **their** childhood. **They** were fixating on an unrelated problem and assigning blame to someone or something else. Rather than face what's really bothering **them**, like social distancing, **they** were deflecting that pain onto something else.

Tamara was struggling and in distress. I reminded myself of my commitment to support **them** through tough times without taking over or taking ownership of problems that weren't mine. I had told Tamara I would look into the matter of lawyers who take on medical

malpractice suits. But my first—and last—step on the task included more research, as I'd suggested Tamara do **themself**. I discovered it is a common practice, recognized by the FDA, for physicians to combine these two medications. I didn't pursue the issue any further. I waited to see if Tamara would follow up with me.

They never did.

THE MATTHEW PROJECT

I would have given anything to spare Matthew the pain, anger, and depression he suffered growing up. *Had I failed him?*

One day, when Matthew was approximately ten years old, my mom stopped by for a visit. I seized the opportunity to have an adult conversation and disclosed a story about some conflict or problem related to Matthew. I was feeling frustrated and helpless. She tried to comfort me by saying that The Matthew Project wouldn't always be so difficult. The Matthew Project! This was precisely the term that summarized my experience with raising this unique child. That day, I thought she was telling me that someday the project would reach a successful conclusion where I would know I'd accomplished what I set out to, and that I would no longer be hostage to the helplessness I often felt, unable to help or soothe or even understand.

I didn't see it then, but my interpretation of my responsibility with The Matthew Project did Matthew and I both a great disservice. The loop I'd created for Matthew, where he achieved a goal only to have a new one set for him, left him feeling as if he was never good enough.

There was always something else he had to do to please me, which meant, in his mind, he had to do something else to earn my love. While I know that my love for him was never in question, I can see now why and how he understood it that way. I harbor deep regret that for so many years I could not stop and recognize what I was—and was not—doing. In my mind it was my fear, concern, and worry that were trumpeting the depth of my love. But no child would understand that. A child needs to hear, see, and feel, over and over and over again, in tangible, explicit ways, that he is loved unconditionally.

I fear I failed Matthew—and Anna—when it came to teaching them how to be happy with themselves. That was my Achilles heel.

How do you teach your children to do something that you don't know how to do yourself?

I didn't really know what it looked like or felt like to be satisfied with myself.

I forgot to celebrate Matthew as a person and celebrate his achievements when he mastered each goal. I didn't use words to tell him how I felt. I didn't whip up a family celebration. I didn't do a happy dance. I didn't hug him or cry with joy. I didn't even remember to smile. I was so concerned about his future that I wasn't living in the present, valuing the boy in front of me. Sure, sometimes I could laugh at his quirky wit or feel my chest swell with pride when I listened to him play the piano or march with the cub scouts in a parade, but I didn't *tell him* or *show him* how proud I was to see him accomplish each little step that moved him a little closer to an independent adulthood.

Today, I may not feel emotional turmoil to the extent I once did, but it turns out that The Matthew Project isn't about Matthew or Tamara at all. It is about being a supportive and loving mother who sees the clear bound-

aries between my child, **their** experiences and choices, and mine.

When I ceased being Matthew's mother, it felt like I would never be whole again, like the ache and empty spot in my heart would never heal. As Tamara's mom, I have put myself back together and become a better version of myself. I have emerged humbled and changed.

I have a better understanding of the issues **they** face because I listen to Tamara and seek testimonies from transitioned young adults. I absorb their stories and learn about the world through their eyes. I've learned that many —too many—have been rejected by parents and families, leaving them to face a harsh world without a support system. Tamara's experience was difficult enough, even with the support of **their** family, I think it must be inexplicably painful for those left to face it alone.

When Tamara and Shelly were dating, Tamara told us Shelly had not come out to her family, even though she had begun to transition. On the occasions when Shelly saw her family, she presented as her male self. She was afraid her parents would not approve. She was convinced her grandparents, whose religious convictions lead them to be open about their anti-LGBTQ feelings, would ostracize her. Shelly finally disclosed her gender identity when all of her aunts, uncles, cousins, grandparents, and her nuclear family were celebrating a birthday. Apparently, no one yelled, screamed, or got angry, but they told Shelly she was being ridiculous. Shelly left feeling like she didn't matter to them, and that they didn't care if she ever saw them again.

I feel tremendous sadness for people like Shelly, who are rejected by the ones they love when they come out as their true selves. I look forward to a day when LGBTQ people can live their lives without the fear or reality of being abandoned by their loved ones. I also have empathy

for their parents. I believe most parents love their children, but as they face a situation that is entirely new, they're confused, and don't know how to navigate their way through it.

Many of us so-called trans-parents experience shock after our children announce they will transition to another gender. We feel we are losing our child because our child is shedding their identity. Our communities also identify us as *other*: people living outside of social norms. And we worry about how others will accept us, along with how they will accept our child.

Families can come through this experience intact. It's hard work, but it's imperative for the well-being of everyone involved. Emotions run high when we hear our child announce that they are pursuing a path we don't understand, and perhaps disagree with, but it is possible to live through those intense feelings *and* let our children know how much we love them.

With time, my perspective has changed a great deal. I didn't really lose Matthew. Matthew just never became an adult. I have memories of all the times we spent together. I don't feel the need to rearrange those memories into a new narrative that identifies Matthew as a girl instead. A boy named Matthew was here. Tamara emerged in early adulthood, and **they** are a lovely nonbinary person who will *always* be a part of our family.

I realized the extent of my change in perspective, and my sense of being on the periphery of my community, one spring day at school. I attended a meeting with a student's parents, two colleagues. When we finished our discussion, I walked the parents to the school door and returned to the conference room. My colleagues were giggling and exchanging remarks about the father's homosexuality, which made me feel uncomfortable. I'm reasonably sure I would have felt discomfort *before* Tamara's arrival, but on

this day, I realized there was more to my reaction than a response to the poor manners these women were showing. I felt empathy for the struggle, pain, anguish, and forgiveness these parents must have worked through to get to where they could present a united parental front. They were raising their two children together, even though one of them left the marriage to live as an openly gay man. I didn't find their situation funny at all. I found it heartbreaking, heartwarming, and inspiring, all at the same time.

I was acutely aware I was an outsider in the conversation these women were having. And my empathy for this family's situation separated me from the herd. I preferred to be an ally to the marginalized than live my life blind to their needs.

I started this journey as a new mother. I was confused, exhausted, and depressed. I went on to embrace the challenge of providing both my children with a variety of experiences and opportunities for learning. At times, it was me against the world as I fought for Matthew's future. My story of motherhood involved working through layers of grief and change. All of this taught me to accept my children for who they are.

A new chapter lies before me as I find my identity apart from my children's day-to-day adventures. Each stage has molded me into a wiser, stronger, calmer, and more patient woman and mother.

I am proud of Tamara. **They** have made a strong and courageous step to free **themself** from the pain and lies that kept **them** miserable throughout much of **their** earlier years. **They** are willing to live with the risks associated with that decision.

While I may not agree with every decision Tamara makes, I am **their** ally. I find it helpful to focus on how much I love **them**. I still pray for **them**. I hope **they** love

God, **their** family, and **themself.** **They** are living a life I know little about and have little to offer as far as advice, experience, or wisdom. I trust **they** will find **their** way through life as a nonbinary person using trial and error.

Just as it is true for mothers everywhere, it's time for me to let go and let **them** live **their** life as an adult on **their** own terms. I am sad when things go badly for **them**, but I celebrate the moments when **they** get things right.

It's a victory when I see **them** shine.

THE PICTURE WALL

*T*he next step in my journey towards healing is to pull out the basket of pictures that sits in on a shelf in my closet. Pictures that once proudly proclaimed the joys of family life deserve a better home. I haven't yet felt motivated to deal with them.

It's time to redefine what the picture wall is and to bring it back into our family story, in a way that respects every member of our family. I will assemble a new family album titled *The Picture Wall*, and I will keep it on our bookshelf of scrapbooks. The pictures, with their assorted memories, will be accessible to those who want to open the book. This includes Tamara.

When I turn the pages of a scrapbook now, I am tangled in a complicated web of emotions. Only recently has Tamara been able to reminisce about **their** childhood. Our stories have a strange quality to them. There is a common thread based on facts, but our perspectives differ.

I am challenged, now, to rewrite the script in my head. I still hold on to the memories as I perceive them, but accept that there may be more to each story than I was aware of. Reframing memories through Matthew's experi-

ence often leaves me feeling irrelevant and left behind in Tamara's world. Even though Matthew is *dead*, according to Tamara, I was his mother. I am also Tamara's mother. Because I want to strengthen my relationship with Tamara, it is imperative I transition from being the mother of one to the mother of the other—indeed, the mother of both.

It's time for me to let go of the question, "What was real?" and accept that both versions of the story can be true at the same time.

I have adjusted my expectations of what our family is supposed to look like and what my role is as a mother. I no longer feel the need to pave the way for Tamara—or as **they** would say, *control everything*. I am working on becoming an open-minded mentor and a soft place to land when **they** need support. I can do that because the emotional roller coaster that followed Tamara's introduction taught me to focus on what's important in my life.

I love ~~him~~ ~~her~~ **them**.

ACKNOWLEDGMENTS

Before I ever wrote a word of this book, I gathered my family around the dinner table and shared my vision. I asked them, especially Tamara, for their blessing. Dave enthusiastically agreed. The kids, however, looked at me in confusion, followed by horror. We are a family that values privacy, and here I was, telling them I wanted to write a book about our most private moments. Was I nuts? I had this wacky idea that our experiences might help others in the same situation. Anna dubiously nodded her assent. Tamara hesitantly agreed, but insisted I change everyone's names.

And so I began.

It is with my deepest gratitude that I thank my family. Dave: for being my partner and strength in all things, including your support through the wild times that went into pulling this book together. Anna: for trusting me to be honest, but not so honest that all of our crazy hangs out. And Tamara . . . I know you don't want to relive any of this, much less read it in print, but thank you for giving me your permission to publish it, even if you can't give me

your blessing. Thank you for being who you are, and for having the courage to live your life authentically.

Thank you to all of my family and friends who supported us throughout The Matthew Project and beyond. You loved us as we were, embraced Matthew's quirkiness, and comforted me during tough times. To those of you who listened to me endlessly brag, whine, cry, and laugh as I brought my story to life, but wouldn't let you read it, thank you. Thank you for believing in me. Whether you recognize yourself in this story, I hope you feel the love and gratitude I have for all you've done.

Thank you to Boni and John Wagner Stafford of Ingenium Books. Thank you for your guidance and hard work to bring this book to publication. It's been an adventure for sure, and your conviction about the value of this story carried me through to the end. Thank you for walking this neophyte through the process. I've learned so much from you. You've helped me achieve a lifelong dream, and I am so grateful.

To *The Picture Wall* (both the book and the wall): I never realized at the time exactly how powerful a force you were to me. Thank you for being my guide through motherhood.

C.A. Gibbs

ABOUT THE AUTHOR

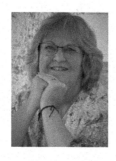 C.A. Gibbs is the author of the memoir, *The Picture Wall: One Woman's Story of Being ~~His~~ ~~Her~~ Their Mother*. Ms. Gibbs is the proud mother of two adults, one daughter and one nonbinary person. Motherhood, for her, has been defined by the autism, transgenderism, and mental illness experienced by her oldest child.

Ms. Gibbs is also a writer, transcriptionist, former elementary school teacher, wife, daughter, sister, friend, and proud dog-mom to a rambunctious golden retriever. She and her husband are enjoying an empty nest, but they joyfully celebrate times when the kids come home and fill the house with noise and laughter.

While Ms. Gibbs takes her work seriously, she relaxes when she camps, plays board games, visits with friends over coffee, and gets to binge-watch crime dramas.

IF YOU LIKED THE PICTURE WALL

*I*f you enjoyed *The Picture Wall*, please consider leaving a brief review on the publisher's website, ingeniumbooks.com/c-a-gibbs, Goodreads, or with the retailer where you bought the book.

Please type this link into your browser to easily go to the Amazon review page: https://ingeniumbooks.com/TPWreview.

Reviews are very important to authors. Your feedback doesn't have to be long or detailed. Just a sentence saying what you enjoyed.

Please accept my thanks if this is something you'd like to do.

C.A. Gibbs

Made in USA - Kendallville, IN
1206995_9781989059609
.12.04.2020 2215